Printmaking Unleashed

More Than 50 Techniques for Expressive Mark Making

Traci Bautista

NORTH LIGHT BOOKS
createmixedmedia.com

Contents

Experiment with found and nontraditional objects to create unique mark-making tools using hot glue, needlepoint canvas, string, cardboard, silk and more! Then use these handmade tools to explore dozens of step-by-step exercises to create expressive marks on your canvas.

Combine digital and traditional printmaking techniques using a Plexiglas sheet to build interesting layers of prints. Delve into printmaking to build acrylic skins and create expressive marks with dimensional paint, water-soluble media and plastic freezer bags.

Become inspired by fun, creative jumpstarts illustrating how to combine printmaking techniques and tools in endless ways. Develop your own signature style through creative exercises and project ideas like art journals, fabric painting, color inspiration and much more!

Your creative toolbox can be filled with a variety of paints, mediums, found tools and mark-making items. I am forever hunting for things I can use to make a unique mark. Here is a list of my favorite mixed-media tools. Visit the Resources page on page 124 for details on where to find some of my favorite supplies!

Surfaces and Paper

chipboard

clayboard

colored construction paper

Dura-Lar

fabric

freezer bags

gessobord

heavyweight construction paper

mixed-media paper

plastic page protectors

Plexiglas

super muslin

wooden building block set

Paints and Mediums

acrylic ink

acrylic paint

archival dye ink

clear tar gel

Collage Pauge (glossy and matte)

crafter's ink

dimensional fabric paint

embossing powder

encaustic paint sticks

encaustic wax medium

fabric paint

fabric sprays

fluid acrylic paint

heavy body acrylic paint

ink sprays

interference fluid acrylic paint

molding paste

pigment ink pad

water-based ink

watercolors

Printmaking Tools

balloons

bottle with fine-tip applicator

cheese cloth

chipboard letters

fiber paste

foam-core board

heat gun

hot glue gun and glue sticks

letterpress machine

Masonite

mixed-media hardbound journal

modeling compound

permanent markers

plastic needlepoint canvas stencils

printmaking barren

rubber stamps

self-adhesive craft foam

silicon brush and blade tools

silk fabric

soft rubber brayer

Teflon

toothpicks, skewers, coffee stir sticks, craft sticks

trowel palette knife

Tyvek envelopes

vintage doilies, lace and trim

wood burning tool

Miscellaneous

2-ply paper towel

anodized aluminum plate

bleeding tissue paper

darning foot

darts

deli paper

embroidery floss and hoop

glitter

grill thermometer

iron

nitrile rubber gloves

pancake griddle

parchment paper

pen

plastic container

plastic syringe

push pins

scissors

sewing machine

sewing needle

small plastic cups

spray bottle

sticks and yarn

texture items: washers, stamps, plastic forks, cookie cutters, wood pieces, tile spacers

thread

How to Use This Book

Pushing the boundaries, thinking outside the box, always wondering and experimenting is how I approach art and life. I am inspired by everyone and everything that enters my path … the texture of a piece of driftwood, a crack in the sidewalk, a fallen leaf in autumn or a blossoming flower. My art is an expression of what inspires me mixed with the things I encounter in daily life. I'm not a trained printmaker, meaning I didn't study it in college, but I have always been fascinated with mark making and finding alternative uses for everyday things.

Printmaking Unleashed is about discovering new approaches to transferring a mark onto a surface and building colorful layers using nontraditional methods. Grab a cup of tea and flip through the book! There is no particular order that you have to start, just open it up and soak in the inspiration. Sprinkled throughout you will find ideas for color palettes, numerous creative prompts and exercises. Each exercise begins with a creative toolbox, which is a jumping-off point for materials. Most items I use to create printmaking tools are readily available at the hardware store, dollar store, thrift store and even in your kitchen or garage. I'm a big believer in creatively using what you have and recycling materials as much as possible. The step-by-step exercises encourage you to make your own marks and can be done in an art journal, on canvas, on fabric or digitally and then incorporated in your mixed-media paintings.

I built *Printmaking Unleashed* upon my previous books, *Collage Unleashed* and *Doodles Unleashed*. In all of them, I encourage you to develop your style and enjoy the process. My main message is to be free and harness that childlike creative spirit where you feel comfortable making marks without fear. My hope is that this book will be a forever reference in your art library—when inspiration strikes, write notes and recipes on the pages. The ideas I present are great starting points, so expand on them and create your own tools. Spend time, even just ten minutes a day, expressing yourself creatively. Simply pick a pen and doodle, make a brush mark on the canvas or write in your art journal and give yourself the gift of creative play. I am truly blessed to do what I love every day. Thank you for sharing in my creative journey!

Live artfully …
traci

Surface Design & Printmaking Tools

The mark of a brushstroke that dances across the page, the drizzle of paint as it flows from the bottle, a stick wrapped with yarn, a silkscreen design made with Collage Pauge, drips of paint from balloons popped with darts, vintage lace and trim suspended in an embroidery hoop, wooden pyrogravure stamps, textured printing plates made from melted wax and toothpicks, the bottom of a water bottle, hot glue stencils and craft foam inscribed with a skewer. What do all these have in common? Each one makes a unique mark, an impression on the canvas that helps express a window into our creative soul. I've always longed to find ways to incorporate different found objects into my art—items that you would not necessarily think to use as a painting tool. I am open to the world of possibilities and am always asking "what if?" I encourage you to take that same point of view and look with new eyes at the materials in your everyday life, things that are sitting right in front of you, and start to imagine all the ways you can creatively use nontraditional items to make expressive marks in your art.

In this section you'll be encouraged to create a variety of handmade mark-making tools from found objects. I share a few ideas on how to use these tools to create colorful layers on various substrates. The painting techniques are creative jumpstarts and are meant to lead you to explore intuitively to make the next mark without question. Rummage through your drawers and look for items that can be dipped into paint, formed into stamps or rubbed with crayons to create textural layers. Go on a creative tool scavenger hunt and be ready to paint!

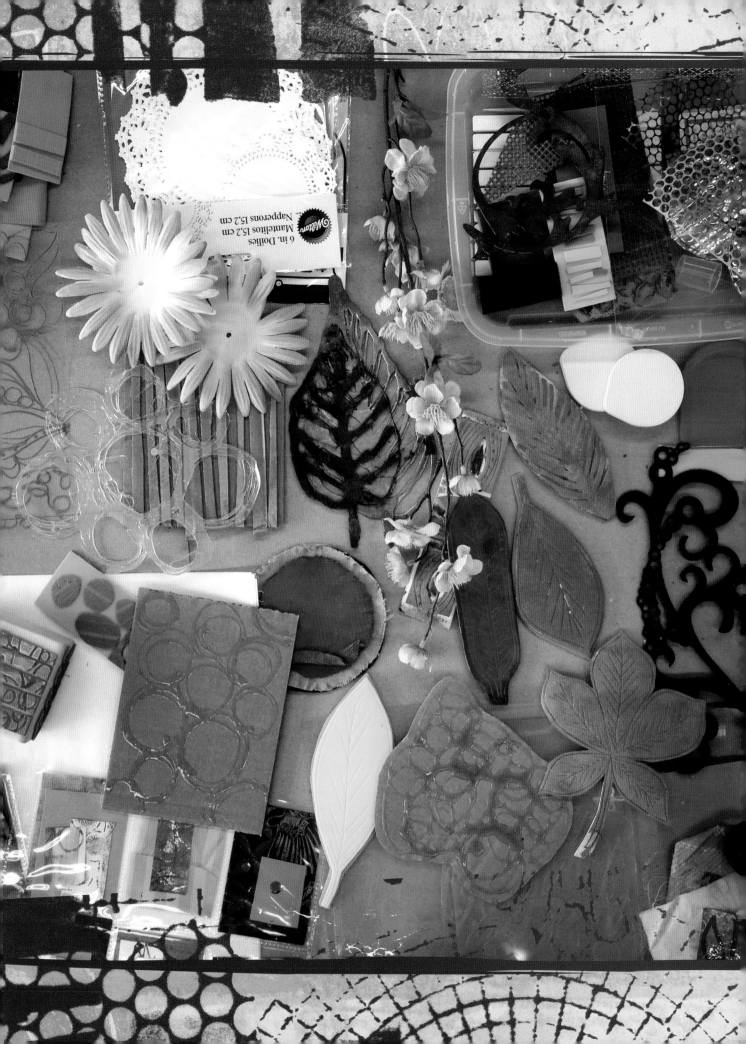

Hot Glue Stencils

Create one-of-a-kind stencils and masks by doodling with a hot glue gun. Hot glue creates a durable plastic stencil that dries quickly and is great for masking off areas in a painting and incorporating a unique mark as a stamp. Once you've created one stencil, experiment with creating a variety of shapes and sizes.

hot glue gun

hot glue sticks

sheet of Teflon or parchment paper

small piece of Plexiglas or a printmaking barren

paint, dye or ink

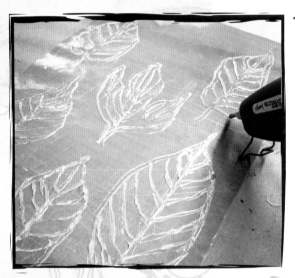

1 Draw Stencils With Heat Gun
Turn on the glue gun and let it heat up. Place a Teflon sheet on the table to use as a base for the hot glue. This will prevent it from sticking to the surface and protect the table.

Place the tip of the heat gun lightly to the surface and press the trigger while drawing interesting designs onto the Teflon sheet. Let the glue dry. Make sure that the stencils are connected in one piece. If the glue does not fully connect, the stencil will be too delicate and fall apart. If this happens, place the stencil back onto the Teflon sheet and add more hot glue.

2 Burnish for Flat Stencils
To create a flat surface on both sides of the stencil, place another Teflon sheet or piece of parchment paper over the top of the glue while it's still hot and burnish over the top with a small piece of Plexiglas (5" × 7" [13cm × 18cm]) or a printmaking barren. When completely cool, use your fingers to slowly peel the stencils from the Teflon.

3 Spray With Acrylics

Place your stencil onto a surface and spray over the top with acrylic, fabric, watercolor or dye ink sprays. The colors will blend when wet, so start with just two colors and let the painting dry before adding a third color. This will help avoid creating brown or "muddy" colors.

Experiment!

Experiment with a variety of glue guns. The mini guns create smaller lines and more delicate stencils. I prefer Aleene's Ultimate Glue Gun because it comes with a variety of interchangeable nozzles for unique marks.

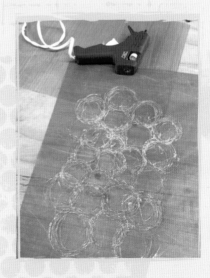

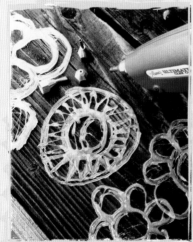

Printing With Hot Glue Stencils

Now that you've created the hot glue stencils, there are a few different ways to use them to make interesting marks and layers in your mixed-media paintings. They can be used both as stencils and masks, or as stamps for making prints. In this exercise you'll create a print using a dyed paper towel.

2-ply paper towel

fabric, super muslin or mixed-media paper

hot glue stencil

fabric sprays or mixes of acrylic and water-based inks in a spray bottle

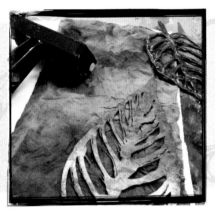 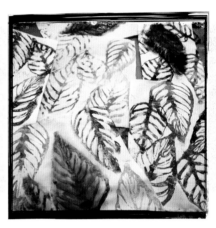

1 Dye Paper Towel

Saturate a paper towel with spray inks or acrylic paint mixed with water using a foam brush to apply it to a paper towel. Cover the entire paper towel with paint to ensure a solid print.

Place the wet painted paper towel onto your fabric or paper surface, then place the hot glue stencil over the top and brayer. This will transfer the paint from the paper towel onto the surface and create a multicolored print.

2 Continue Printing More Stencils

Move the painted paper towel over to another area on the fabric and repeat the braying process to print other stencils.

3 Reveal Print

The final design will reveal various multicolored prints with a watercolor look and feel.

Hot Glue Stencil Tips and Ideas

* When creating word stencils, make sure that the letters connect to form one piece. It will be much easier to paint.
* Always remember to turn off the hot glue gun and work safely. Do not touch the hot tip of glue gun with your fingers.
* Once the stencil is completely covered with paint, it can be used as an embellishment. Add a string to create an ornament or use as a decoration in a handmade card.
* Scan or take photos of the stencils and painted backgrounds to use as digital elements or collage sheets.

Stamping With Hot Glue Stencils

Try it with multiple stencils and colors!

soft rubber brayer

acrylic paint

1-inch (2.5mm) foam brush or foam pouncer

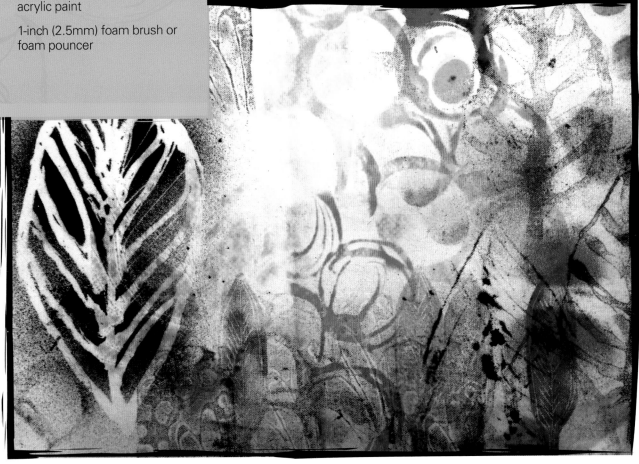

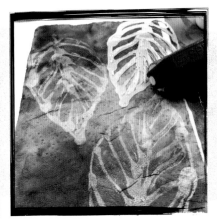

1 Apply Paint
Apply fabric paint onto the flat side of the stencil using a foam brush or foam pouncer.

2 Print Painted Stencil
Place the painted stencil onto the surface and roll over the top of the stencil with a soft rubber brayer to make a print.

3 Move Stencil
Move the stencil onto another area of substrate until all paint is transferred from the stencil. Let it dry.

Visit artistsnetwork.com/printmakingunleashed for free bonus printmaking projects

printing Tool
Free-Motion Stitched Foam Stamps

<< Creative Toolbox

For a twist on stamping with craft foam plates, add free-motion stitching to create textures in hand-cut stamp.

adhesive and regular craft foam

sewing machine and thread

embroidery floss and sewing needle (optional)

darning foot

scissors

1 Free-Motion Stitch Craft Foam
Set your sewing machine to free-motion stitch according to manufacturer guidelines. Drop the feed dogs and use a darning needle to free-motion stitch interesting designs onto craft foam. Move the craft foam slowly around to doodle designs with the thread. I like to stitch random shapes as well as flowers and geometric shapes.

2 Cut Stitched Foam Into Stamp Shapes
Use scissors to cut the stitched craft foam into circle or flower shapes creating unique stamps. Cut pieces of adhesive craft foam to match the shapes of the stitched foam and adhere to the backs. This gives the stamp a heavier base and makes it easier to use.

3 Create Larger Stamp
Cut rectangles and elongated circles out of stitched and plain adhesive craft foam. Use both the positive and negative shapes to create a larger stamp. Peel off the backing and adhere the pieces to a 5" × 7" (13cm × 18cm) sheet of craft foam. You can also create a double-sided stamp by etching into the backside of the craft foam.

Embossed Prints Using Foam Stamps

<< *Creative Toolbox*

free-motion stitched craft foam stamps

mixed-media journal paper

embossing powder

heat gun

fluid acrylic paint and spray inks

hot glue stencil

brayer

1-inch (2.5mm) flat brush

archival dye ink

pigment inkpad

Create a colorful, textured art journal background with embossed images using handmade free-motion stamps.

1 Stamp and Emboss Ink
Stamp a free-motion craft foam stamp pattern onto mixed-media journal paper using ink. While the ink is still wet, sprinkle on embossing powder, glitter or flocking powder. Heat the embossing powder with a heat gun to activate until it begins to shine and becomes dry.

2 Print with Stencils
Once the embossing powder is dry, add more layers. Spray ink through a hot glue stencil. After the stencil has been used as a mask and is still wet with paint, turn over the wet stencil onto the background and burnish with a soft rubber brayer to make a print. Let it dry.

3 Stamp with Dye Ink
Use a wet brush to apply a wash of color over the paper and let dry. Stamp more images over the top using archival inks to create an interesting pattern.

4 Paint Another Wash
Add a final wash of paint over the top of the dried ink and paint using a flat brush. This will help pull the page together.

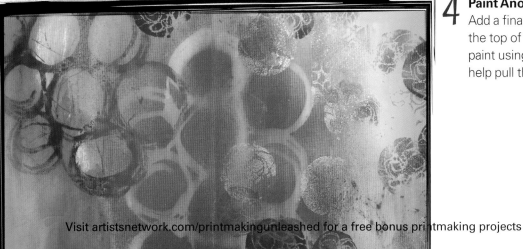

Visit artistsnetwork.com/printmakingunleashed for a free bonus printmaking projects

String, Fiber and Rope Texture Plates

Go on a hunt for interesting textures and chunky fibers to have on hand! Found materials like cardboard, doilies, string, fibers, rope with molding paste, decoupage and tacky glue are perfect for creating unique printing plates.

flat plastic container

Collage Pauge glossy

cardboard

1-inch (25mm) foam brush

various strings, raffia, yarn, rope or twine

scissors

tacky glue

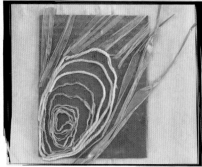

1 Brush on Collage Pauge and Add String

Pour Collage Pauge into a flat plastic container. Apply a layer of Collage Pauge onto a piece of cardboard with a foam brush. Saturate a piece of string by dipping it into the Collage Pauge, then place it onto the cardboard to create a pattern.

2 Add Fibers and Raffia

Continue to add a variety of dampened fibers and string to the cardboard. Brush more Collage Pauge onto the cardboard and add raffia to finish off pattern. Trim off excess fibers and raffia with scissors.

3 Adhere Twine With Glue

To adhere heavier fibers, squeeze tacky glue in between raffia, then press twine into wet glue. Finish off the texture plate by adding more glue and twine to the desired effect.

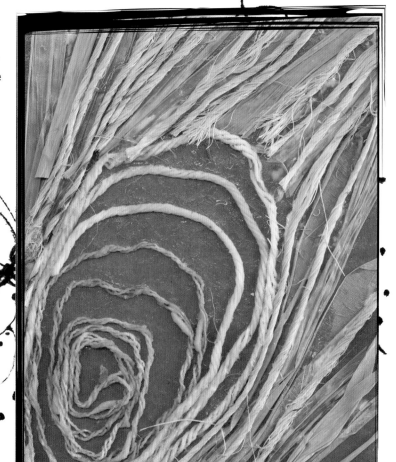

Pyrogravure Wood Blocks on Fabric

Pyrogravure is the art of decorating wood with burn marks made with a heated tool. Turn kids' wooden blocks into handmade stamps by inscribing them with doodles and heat tools.

wooden building block set

woodburning carving tool

fabric and acrylic paint

fabric or soft muslin

1 Draw Designs in Wood Block
Attach the desired nib and turn on the heat tool. Place the hot tip of the tool to the wood and draw the design. Doodle into the wood with the tip of the heat tool.

2 Paint Block
Apply fabric paint to the textured wood-burned stamp using a foam pouncer in a soft dabbing motion to make sure paint does not get stuck in the crevices.

3 Stamp Block
While the wooden block stamp is still wet, press it onto a fabric surface like super muslin. Repeat the stamped pattern until you are satisfied with the look and feel.

This art journal page has been stamped with pyrogravure blocks, stencils and found tools:

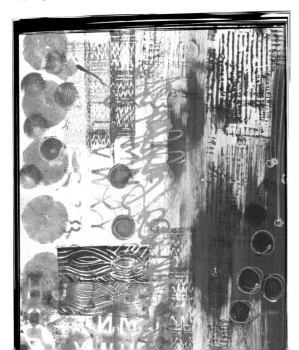

Pyrogravure Tips and Ideas

* Make sure the carving tool is turned off and cool when changing tips and work in a well-ventilated area.
* Draw a pattern or design into the wood with a pencil to use as a drawing guide.
* To achieve a better quality print, make sure to place a piece of felt or a towel underneath to provide a better cushion for stamped images.
* If your design has tiny intricate marks, place your fabric over the top of the painted wooden block and burnish with a spoon or barren to help transfer the entire print.
* Use a smooth fabric like muslin or drill cloth for an even print. Fabrics with a lot of texture like duck cloth may not print the design clearly.

Printing With Needlepoint Canvas Stencils

The geometric designs of plastic needlepoint are perfect for creating unique stencils. Cut and create custom shapes to use as stamps, texture plates and masks. In this exercise, let's use needlepoint canvas with spray inks to paint an art journal page.

- painted substrate
- plastic needlepoint canvas stencils
- various spray inks, watercolors or homemade acrylic sprays
- spray bottle
- heavyweight construction paper
- acrylic paint
- soft rubber brayer
- scissors
- 1-inch (25mm) foam brush
- Collage Pauge matte
- fine-tipped black pen or marker

 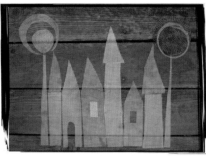

Needlepoint Canvas Stencils
A variety of shapes cut out of plastic needlepoint canvas: flowers, circles, a house and other fun designs.

1 Place Stencils
Using a dark painted background as the substrate, place various needlepoint stencils over the top. Here I used paper painted with the balloon splatter method (see page 39).

2 Spray Ink
Spray the stencils with either spray ink, liquid watercolor or water-downed acrylic in a spray bottle. To produce an even coat of color, press the nozzle of the spray bottle as you move over the page from right to left. This helps avoid puddles in one area.

3 Print Stencil
While the stencil is still wet, flip it over onto another section of the paper to make a print. Continue to print the stencil until all paint is removed.

Needlepoint Canvas Tips and Ideas

- * Draw on the needlepoint canvas with a black marker if you need a guide.
- * Place a cutout shape onto the canvas and trace it with a black permanent pen or water-soluble pencil.
- * Experiment with sewing yarn or raffia into the needlepoint canvas.
- * Clean painted stencils off onto another journal page or scrap paper to use up all the excess paint before switching colors.
- * Wipe off the rest of the paint onto a wet paper towel or baby wipe.

 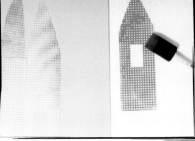 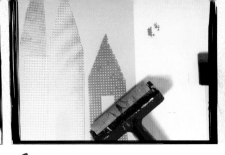

4 Paint Background

Spray through more stencils and let dry. Paint a wash with a wet brush dipped into ink or acrylic paint and add blocks of color with full-strength acrylic paint and a foam brush. Set aside to dry.

5 Create Collage Paper

Place house-shaped stencils on a separate sheet of colored construction paper. Coat one side of a house-shaped needlepoint canvas stencil with fluid acrylics using a foam paintbrush.

6 Stamp Collage Paper

Turn over the painted side of the stencil and roll over the top with a soft rubber brayer to transfer the print to the paper.

7 Stencil Mask

Use the remaining house stencils as masks and spray ink or acrylic mix over the top. Remove the stencils and let dry.

8 Paint Houses and Cut Out Shapes

Add more detail to the house shapes by painting with a darker color. Let them dry, then cut out the house shapes with scissors.

9 Collage the Shapes and Doodle

Using a foam brush, evenly spread a layer of Collage Pauge matte onto the surface. Place the cut-out house shapes over the Collage Pauge, then coat with another layer of Collage Pauge. Use your fingers to smooth out the surface and remove air bubbles. Let it dry.

Let the freestyle painted background inspire your mark making. Here I drew flowers on the page with a black permanent pen. Make sure the paint is completely dry before you draw to avoid ruining the pen or marker.

Visit artistsnetwork.com/printmakingunleashed for free bonus printmaking projects

Puffy Paint and Collage Pauge Plates

Puffy paint and Collage Pauge are wonderful tools for creating deeply textured plates. Drizzle lines, swirls and doodles then use your plates to make prints and rubbings.

craft foam

scissors

dimensional fabric paint

Dura-Lar

construction or kids' storybook paper

oil pastels

deli paper

Collage Pauge

glitter

1 Draw With Puffy Paint
Draw a design on a sheet of Dura-Lar polyester film using dimensional paint. Let it dry completely.

2 Rub Pastel Print
Place a piece of kids' storybook paper over the dimensional paint plate and lightly color over the top with an oil pastel, working in sections over the plate to reveal the print on paper.

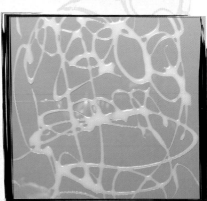

1 Draw With Collage Pauge
Place a sheet of Dura-Lar onto a piece of colored construction paper on top of deli paper. The construction paper will help you see the designs and the deli paper protects your work surface. Shake the Collage Pauge bottle then drizzle the medium onto the Dura-Lar creating freeform swirls and lines.

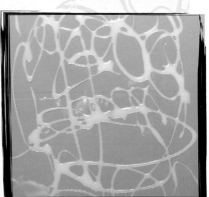

2 Add Glitter Texture
Before the Collage Pauge dries, add texture by shaking glitter over the drizzled design so that it completely covers the wet medium. Allow to fully dry before using the printing plate.

Drizzle Plate Stamps

Cut apart some Collage Pauge drizzle plates to make unique stamps with craft foam and use them to create a simple pattern on paper.

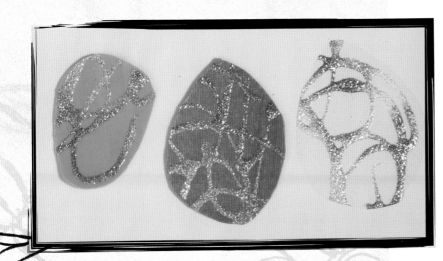

1 Create Stamps

Cut out shapes from the Collage Pauge texture plates you created on the previous page and adhere them to adhesive craft foam. Cut around the shape of the plate to create a few stamps.

2 Stamp Over Dyed Paper Towel

Spray a paper towel with water and place a few drops of fluid acrylic paint. Squeeze the paper towel with your hands until paint covers the entire surface. Place the dyed wet paper towel over a construction paper substrate and press the Collage Pauge drizzle plates into the paper towel. Roll over the back of the stamp with a soft rubber brayer to transfer the texture through the paper towel onto the surface.

3 Final Print

Move the dyed paper towel over sections of the background and repeat the printing process until the paper is full of the stamped pattern.

Vintage Lace Embroidery Hoops

The intricate patterns in vintage crochet doilies and lace make beautiful marks when used for printing. Search for lovely doilies and lace at thrift and antique stores. In this exercise we explore making screen tools using embroidery hoops.

vintage doilies, lace and trim

cheesecloth

scissors

embroidery hoops

1 Cheesecloth Layer

Unscrew the outer embroidery hoop to loosen. Cut two pieces of cheesecloth about 2 to 3 inches (5 to 8cm) wider than the outside of the center hoop. Layer the cheesecloth, overlapping some sections. Make sure it extends over the edges of the hoop.

2 Add Lace and Trims

Cut lengths of vintage trim and lace larger than the width of the embroidery hoop. Lay them over the top.

3 Textured Screen

Place the outer hoop back over the top of the cheesecloth and lace; screw to tighten the hoop. Pull the edges of the cloth and fibers from the back to stretch the fabric tight.

4 Finished Lace Printing Screens

Here are a few examples of vintage doilies and lace sandwiched into embroidery hoops. Perfect for making prints over a variety of substrates!

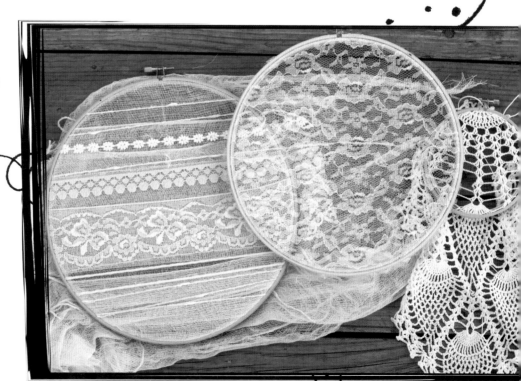

Printing Vintage Lace Textures

Vintage lace fabric screens can be used like stencils and masks with spray inks or painted with acrylic pastes to create textured surfaces. In this exercise we make a print with a lace embroidery hoop screen.

- fiber paste
- deli paper palette
- fluid acrylic paint
- trowel palette knife
- vintage lace
- embroidery hoop screen
- gessobord
- mixed-media paper
- ink sprays

1 Create Colored Paste
Place a dollop of fiber paste onto a piece of deli paper palette. Pour a few drops of paint on top of the paste. Mix the paint and paste using a trowel palette knife.

2 Apply Paste
Place the lace embroidery hoop screen with lace-side down onto the gessobord surface. Using the palette knife, spread the fiber paste mixture onto the back of the screen. This will adhere the pattern to the board. Apply more fiber paste and a few more drops of fluid acrylic onto the back of the screen.

3 Spread Paint
Use the palette knife to spread the mixture through the rest of the screen. Apply more paste if needed to cover the entire screen. Let sit for 10 minutes.

4 Lift to Reveal Print
Lift the screen to reveal the textured design.

5 Ghost Print
Use up the rest of the paint paste mixture. Place the wet screen onto a piece of mixed-media paper and use the palette knife to press the back of the lace. This will transfer the leftover paint onto the paper. Move the screen to another area of the paper, then spray over the top using ink spray.

6 Cover Surface
Continue to move the lace screen around the paper and spray with ink until the surface is covered to your liking.

Visit artistsnetwork.com/printmakingunleashed for free bonus printmaking projects

Found Tool Stencils

Be on the lookout for interesting items with texture, pattern or shapes. Look around the house, kitchen, garage and garden for objects that might make a great mark. Look with "different eyes" at the bottom of bottles, the tip of a pen, rubber bands, foam hair rollers, the side of a plastic bin … all these things can be incorporated into your printmaking and art. Here are some of my favorite items to use as stencils and printing objects.

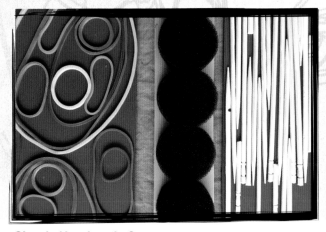

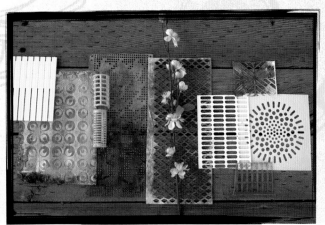

Simple Handmade Stamps
Rubber bands, toothpicks and thin-cut hair rollers pressed into adhesive craft foam.

Simple Found Objects
From left to right: plastic drawer liners, textured wallpaper, hair curlers, Scantron test paper, plastic leaf gutter guard, silk cherry blossom flowers, strawberry basket containers and a sink drain cover.

Spray and Reveal a Print!

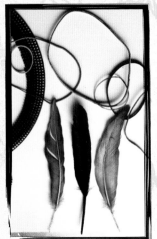

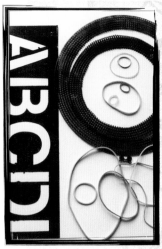

Rubbers bands, feathers and needlepoint canvas rings sprayed with acrylic ink mixture.

Wooden skewers, craft sticks, letter stencils, needlepoint canvas circles and rubber bands on mixed-media paper sprayed with multiple colors of acrylic spray inks.

Chipboard Letter Stamps

My affinity for letters and typography has led me to collect chipboard letters that I use as stamps and masks in my journal pages. I also love creating printing plates that mimic the look of letterpress type when printed.

chipboard letters

adhesive craft foam

scissors

Collage Pauge matte

1 Arrange Chipboard Letters on Craft Foam
Place chipboard letters close to each other with letters facing in different directions. For a smooth print, it's best to work with letters of the same height.

2 Finished Chipboard Plates
Here are a variety of chipboard letter stamps and plates. To create them, peel the backing off a sheet of adhesive craft foam and attach the letters to the sticky side of the foam.

Chipboard Tips and Ideas

* For easier printing, choose chipboard letters of the same height.
* Seal the chipboard with Collage Pauge matte and let dry before the initial use to help them last longer.
* To use with acrylic paint, brush on even coats with a 1-inch (25mm) foam brush.
* To use with stamp pads, place the plate face-side up and press the stamp pad onto the surface of the stamp (rather than pressing the chipboard into the stamp pad).
* Since the chipboard is hard, stamp on a soft surface to get a better impression by placing a piece of felt or towel underneath the surface.
* If the chipboard letters are different heights, place the printing plate underneath the substrate and use a spoon or printmaking barren to burnish the print into the paper.
* Don't try cleaning the chipboard stamp in water or it will fall apart. Instead, continue to use the stamp until all the paint is used up. Then wipe it onto a clean-up sheet of paper or in your journal.
* After a while, the printing plate gets full of paint and adds great texture to the prints—enjoy!

Wax Stamp Resist

Working with a hot plate and encaustic paints, create a stamped background using a chipboard letter plate. Create collage papers or journal pages with transparent, waxy layers of color.

anodized aluminum plate

grill thermometer

encaustic paint sticks

nitrile rubber gloves

chipboard letter stamp plate

sketch paper

printing barren

1-inch (25mm) foam brush

acrylic paint

1 Melt Paint
Heat the anodized aluminum plate to working temperature of 150°F (66°C). Use a thermometer to monitor the temperature so it doesn't get too hot. Apply encaustic paint sticks directly onto the hot plate with an even pressure, moving around to melt the paint in a square shape.

2 Chipboard Stamp
Transfer the encaustic paint onto the chipboard stamp plate while it is hot.

3 Coat Stamp
Place the chipboard stamp onto the melted encaustic paint and press the back of the stamp. Rub the back of the stamp with your hands to transfer the melted paint.

4 Painted Stamp
This shows the hot encaustic paint on the chipboard letter stamp plate.

5 Transfer Print
Place a piece of sketch paper onto the hot plate, then place the painted stamp over the top and use a printmaking barren to press the image into the paper.

6 Printed Paper
This is the final printed stamp image on the paper. It's not a perfect print, but that's okay. It's because the chipboard stamp has a lot of texture left from many paint layers covering the letters. Repeat the process to add more wax stamped onto the paper.

7 Scribble Design
Place the painted paper face up over the heated aluminum plate and scribble over the top using an encaustic paint stick.

8 Apply Wash
Fill in the white background with color. Dip a 1-inch (25mm) foam brush into fluid acrylic paint mixed with water and brush it across the surface.

Encaustic Tips and Ideas

* When working with encaustics, always use proper ventilation and wear recommended protective gear.
* Keep encaustic paint temperature at 150°F (66°C) for printmaking.
* Experiment with a variety of papers. I like sketch paper; paints tend toward a more translucent quality because of its thin quality. I like printmaking paper for heavier applications and to produce vibrant prints.

9 Fill Page
Continue to paint the wash until the page is completely covered with paint.

Visit artistsnetwork.com/printmakingunleashed for free bonus printmaking projects

Mark Making With Sticks and Yarn

<< Creative Toolbox

sticks

yarn

embroidery floss

construction paper

fabric and ink sprays

fluid acrylic paint

small plastic cup

Sticks and branches have always been tools in my mark making. I especially love the marks that they make when dipped into India or sumi ink. Objects found in nature are great for giving artistic marks an organic look and feel. Collect sticks and fallen branches and twist yarn or twine around them to create a tool.

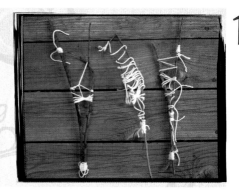

1 Wrap Sticks

Tie yarn around the branches to create a web effect. Wrap it around one area of the stick a few times. Continue to loosely wrap yarn around sticks and weave it over and under each branch. Wrap some of the woven yarn areas with embroidery floss or more yarn to tie it off.

2 Spray Stick Pattern

Place the stick and yarn tool onto a piece of construction paper. Spray ink from the bottle over the top of the tool.

3 Cover Page

Turn over the stick tool so the wet yarn touches the paper. Press it into the surface to make a print. Continue moving the stick and yarn tool around the paper and alternating ink spray colors until the page is full of the pattern.

4 Paint With Stick

Pour a little fluid paint into a small plastic cup and dip the end of a stick into the paint. Draw with the end of the stick, making marks across the page.

5 Add White

In another plastic cup, pour some fluid acrylic white and dip a stick into it. Make dots with the stick on the dark areas of the page to lighten it up and mix other areas of color. Using the sticks as resists and mark-making tools creates an organic expressive quality in the artwork. Experiment with various branches and objects found in nature to make interesting marks.

Toothpick and Skewer Texture Plate

Create a fun and simple texture plate using various toothpicks, skewers and craft sticks. You can also experiment with pyrogravure on the toothpicks to burn patterns into them before attaching them to craft foam.

toothpicks, skewers, coffee stir sticks and craft sticks

adhesive craft foam

scissors

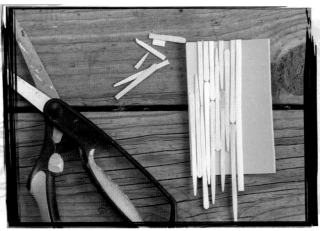

1 Adhere Wooden Pieces
Place toothpicks and skewers onto the adhesive side of craft foam.

2 Trim Excess
If parts of the wood pieces are hanging over the edge, cut them with scissors.

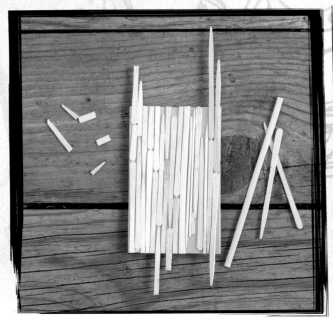

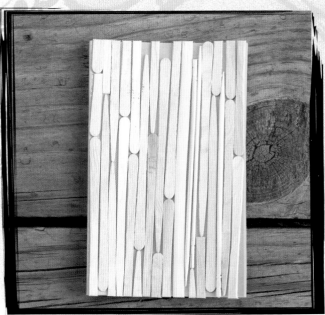

3 Add More Wood
Finish off the texture plate by adding more pieces of wood until the entire piece of craft foam is full.

4 Toothpick Texture Plate
Trim the excess pieces again. Print with the toothpick plate or use it for rubbings.

Visit artistsnetwork.com/printmakingunleashed for free bonus printmaking projects

Encaustic Texture Plates

Experiment with ways to create deeply textured printing plates using encaustic wax medium. Explore building texture with this interesting medium by heating it and drawing into it with a skewer. Once the wax is cooled, it holds its shape and makes a great printing plate. You can use it by itself as a stamp or as a printing plate with a makeshift press from a tabletop printing or embossing machine. Prepare the textured plate then run it through a letterpress machine converted into a press (see facing page).

pancake griddle

grill thermometer

encaustic wax medium

1-inch (25mm) natural bristle brush

5" × 7" (13cm × 18cm) Plexiglas plate

clay carving tool and skewer

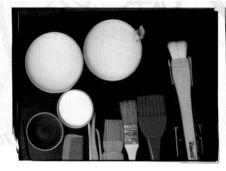

1 Heat Wax Paint
Turn on the pancake griddle and set it to 150 to 175°F (66 to 79°C). This temperature is recommended by the manufacturer. Place a thermometer on the top of the griddle to monitor the temperature.

2 Melted Wax Circles
Dip natural bristle brush into the wax medium and paint a few brushstrokes on the Plexiglas. As it dries, the color of the wax will change from clear to translucent.

3 Inscribe Wax
With a clay carving tool begin to carve into the wax with the end, drawing circles and scraping away pieces of wax.

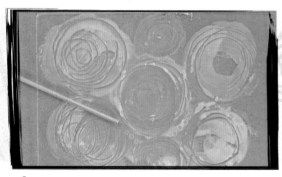

4 Make Marks
With the bottom of the skewer add tiny circle shapes in the wax by pressing it into the surface. Continue to make marks until you are satisfied with the design.

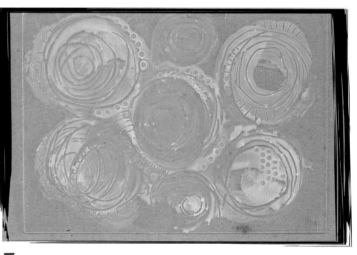

5 Fine Details and Cooling
Use the pointed tip of the skewer to draw additional thin lines and add more detail. Let encaustic plate sit and cool.

Printing Encaustic Plate on Fabric

The encaustic plate created on the facing page is fully detailed but with an uneven texture. To obtain a clean even print, it helps to apply a lot of pressure. For this technique, I used a Fiskars Fuse letterpress machine. Experiment with any other die-cut or embossing machine as long as the encaustic plate will fit.

1 Apply Fabric Ink
Apply fabric ink to the encaustic plate laid flat on your work surface. Place the entire face of the ink pad onto the encaustic plate until it is completely covered with ink. I used fabric ink because I'm printing on muslin.

2 Prepare Printing Plate
Place the inked printing plate face up on a piece of 12" × 12" (30cm × 30cm) chipboard. Next place a piece of heavyweight muslin over the plate.

3 Cardboard Sandwich
To run the plate through the letterpress machine, add 5 to 8 layers of recycled material like cardboard on top of the printing plate and fabric.

4 DIY Press Inserts
Here's a sampling of all the materials I sandwich in between the press. Include a piece of felt to help absorb the pressure.

5 The Print
Turn the crank handle on the letterpress to move the printing cardboard sandwich through the machine. Pull out all the layers of cardboard, felt and chipboard. Here's the first print.

6 Ghost Print
Place the encaustic plate back through the machine and repeat steps 3 to 5. Each time will result in a lighter print.

Fabric Stencil Prints

Hand-cut stencils are one of the simplest DIY tools to make for creative mark making. Snowflake stencils made from construction paper are perfect for printing on fabric, especially for winter crafting and journaling projects. I love the surprise organic shapes that appear when you open the snowflakes. The final painted fabric remnant can be used to create an art journal cover or to add free-motion stitching for an art quilt.

12" × 18" (30cm × 46cm) construction paper

scissors

drill cloth fabric

fabric sprays

soft rubber brayer

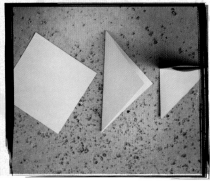

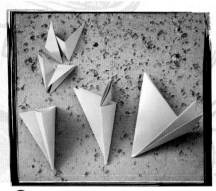

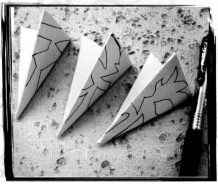

1 Fold Triangles
Begin with square-shaped papers, then fold in half to create triangles. Fold each in half again to create another triangle.

2 Fold in Thirds
Take each triangle and fold into thirds; you'll have small flaps on the top. Trim off the edges to create a cone shape.

3 Draw Designs
Draw random shapes onto one side of each folded paper. Make sure to draw the lines to the edge so when cut, the stencils do not fall apart. Experiment with different patterns.

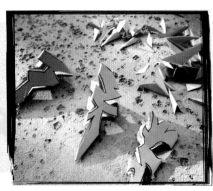

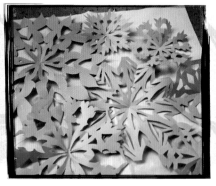

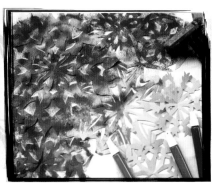

4 Cut Designs
With scissors, cut out sections of the paper.

5 Lay Out Snowflakes
Unfold the cut papers to reveal the snowflake shapes. Lay them out on a piece of drill cloth.

6 Spray Paint
Pick two or three colors of fabric sprays and spray over the stencils. The colors will blend when wet, so avoid choosing all three primary colors at once or you'll create a muddy mix. To keep colors from blending, let the paint dry in between layers.

7 Make Print
While paint and stencil are still wet, pick up the stencil, turn the painted side over and place it onto the fabric surface. Roll a soft rubber brayer over the back to transfer the paint to the fabric. This will result in a positive print of the stencil.

8 Painted Fabric
Continue to spray paint through the stencils and take prints until the fabric is completely covered. Here is a final project.

9 Embellishments
This is a collection of the painted paper stencils. Once you are finished painting with the stencils, you can use them as collage pieces for your journal or decorate holiday packages with them.

Paper Stencil Tips and Ideas

This is a quick and easy way to create masks and stencils! All you need is a pair of scissors and paper. Use copy paper, file folders, Tyvek envelopes, construction paper or mixed-media paper. Each type of paper you use will result in slightly different prints. Thicker folders or mixed-media paper will yield a longer lasting stencil. Once you are finished using the stencils in paintings, they can be used as embellishments for art journals or for collage.

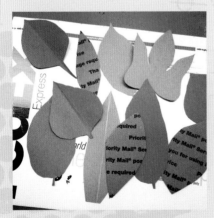

Recycle mailing containers. Leaves cut from mailing envelopes and cardboard mailing boxes. Once these are painted, they can also be used to create ornaments.

Symmetrical designs. Fold copy paper or Tyvek envelopes in half and cut out design.

Heart stencils. A quick and easy way to create a heart. Fold a piece of paper in half and cut out half of a heart.

Painted Collage Pauge Silkscreens

Collage Pauge is not only a medium for gluing items to a canvas, it can also be used as a mask or resist. Here we mix it with water-color and paint it directly on a piece of silk to create a silkscreen.

- embroidery hoop
- silk fabric, nylon or a thin, sheer fabric like cheesecloth
- Collage Pauge glossy
- small round and flat paint-brushes
- watercolor paint
- plastic container

1 Cut and Secure Silk
Cut a square of silk material about 2 inches (5cm) larger than the embroidery hoop. Place it in the frame and tighten the top screw. Pull the excess material around the edges to tighten it in the hoop and the fabric 1 inch (25mm) from the edge so there is enough hanging out to pull tight, if needed.

2 Paint Screen
Mix Collage Pauge glossy with a drop of high concen-trated watercolor paint. This is done to help you see the brushstrokes you paint when it dries. Begin to paint a pattern with a round paintbrush. Start at one end, then work your way around to the other side of the silk.

3 Add Doodles and Let Dry
Continue to fill up the silkscreens with more designs, painting on the dyed Collage Pauge with a flat brush. Finish painting on Collage Pauge until you are satisfied with the design. Set aside to let dry.

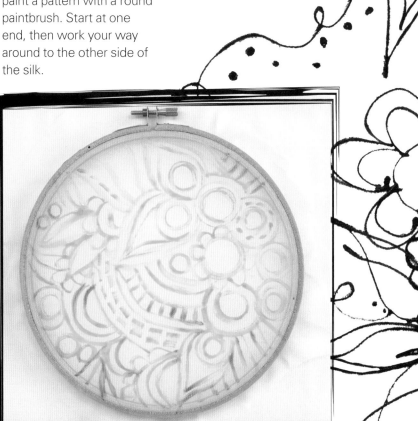

Doodled Collage Pauge Silkscreens

You can also doodle with Collage Pauge using a bottle with a fine tip applicator or by drizzling it directly from the bottle for a more freeform pattern. Experiment with these exercises on creating your very own DIY screens for printing.

embroidery hoop

silk fabric, nylon or a thin, sheer fabric like cheesecloth

Collage Pauge glossy

bottle with a fine tip applicator

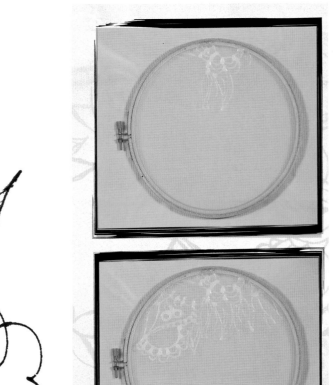

1 Set Up Silkscreens
Place a piece of silk into an embroidery hoop (see facing page for technique). Pour Collage Pauge glossy into a bottle with a fine applicator tip. Place a piece of colored construction paper underneath to help you see the design better. Place the tip of the applicator bottle onto the surface of the silkscreen and begin to squeeze the bottle to draw with the Collage Pauge on one side of the embroidery hoop.

2 Draw Freely
Continue to draw doodles on the silk. Make sure to keep the tip touching the surface and squeeze the bottle lightly as you move it around. Keeping the tip to the surface will help to create even lines and prevent big globs of medium on the screen.

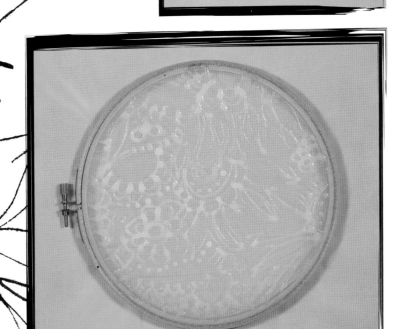

3 Complete the Doodles
Fill in the rest of the screen, working across the silk and being careful not to touch the previous marks. Once the entire screen is filled with the design, set it aside to dry.

DIY Silkscreen Painting With Acrylics << *Creative Toolbox*

Use your DIY silkscreens to print and stamp an authentic screen-printed look on your substrates. The handmade screen is great to print on fabric and even on your art journal pages.

DIY painted silkscreen

construction paper and cardstock

fluid, OPEN and heavy body acrylic paint

plastic paint scraper and palette knife

1 Paint Screen
Place the screen with silk side down onto a piece of construction paper. Squeeze a dollop of OPEN acrylic paint onto the back of the screen. Scrape the paint across the screen with a plastic paint scraper. I like to use an old hotel room key.

2 Add Paint
Squeeze more paint from tubes and drizzle a few drops from bottles onto the screen. Use the paint scraper to spread the paint over the back of the screen.

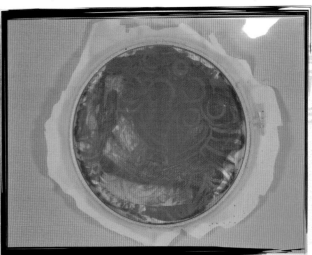

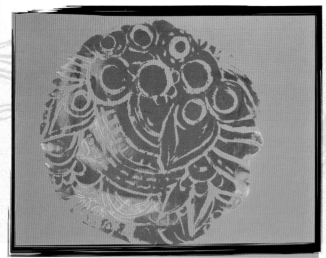

3 Cover Screen
Cover the entire screen with paint.

4 Reveal Print
Lift the screen to reveal the multicolored print on the construction paper.

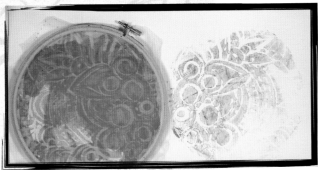

5 Stamp a Ghost Print

You can use the excess paint to stamp more designs with the original painted screen. Place the wet paint-covered screen onto a piece of paper and scrape the back of the screen with a plastic paint scraper. Move the screen around the paper and repeat a couple of times.

6 Add More Paint

Once paint is removed from the screen, apply heavy body acrylic paint with a palette knife onto the backside of the screen and scrape it through the screen with the plastic paint scraper.

7 Lighten Color

Move the screen to a different section on the paper and add more paint. Repeat the scraping process. Move the screen again and add white paint to the back of the screen and scrape it across the surface.

8 Print Reveal

This is the final print on paper. You can use this as a collage paper or a background for a painting.

Acrylic Silkscreen Printing Tips and Ideas

* Use a heavier bodied paint for better print results. I prefer Golden OPEN paints because they stay wet longer and allow you to continue to paint without worrying about the paint drying on the screen too quickly.
* Keep a piece of paper or art journal page on the side to paint ghost prints and use up the rest of the paint on the screen. If you use a spiraled journal, it's a fun way to keep a record of your experimenting and to create unique layered prints to use in collage or other art projects.
* Also try painting smaller sections of the screen and repeat the pattern over a surface.
* Add different colors each time you print the screen to create a multicolored background.

printing Tool

Molding Paste Plates With Found Objects

Molding paste is a versatile acrylic medium which can be inscribed, carved or used to embed items to create textured collagraph printing plates. It's flexible when it dries so it creates an interesting surface when used with heavy interfacing or Lutradur fabric. In this exercise, create a textured plate by drawings and pressing objects into the paste.

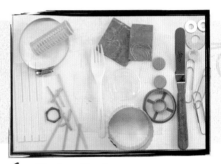

1 Texture Tools
Collect items from your toolbox, hardware store, kitchen and office to use to press textures into the molding paste.

2 Spread Medium
Cover your surface with a piece of deli paper. With a long trowel knife, take a scoop of molding paste out of the jar and spread it evenly using the bottom of the palette knife to move it across the entire piece of fabric in an even layer.

3 Create Texture
While molding paste is wet, press a piece of plastic needle-point canvas into the surface to create a square pattern in different areas of the molding paste. Use a plastic lid cover to create circular shapes in various areas.

4 Scrape Designs
Drag a fork through the molding paste to draw more designs and create texture.

5 Continue Pressing Shapes
To create more circular shapes, press metal washers into wet molding paste, then lift them off to reveal shapes. Stamp a cookie cutter onto the surface of the molding paste. Allow the plate to dry completely.

printing Tool

Molding Paste Plates With Wood Textures

Here's another way of creating a collagraph printing plate using recycled cardboard and found materials from the hardware store.

1 Apply Paste
Scoop out a dollop of molding paste onto a piece of recycled cardboard and spread it evenly across the surface using a trowel palette knife.

2 Adhere Found Objects
Press pieces of cut wood embellishments. It's helpful to have the texture pieces that are the same height to obtain a nice even print.

3 Fill Up Plate
Add plastic tile spaces and more wood pieces to fill up the cardboard.

Texture Plate Tips and Ideas

* Use it as a rubbing plate texture.
* Paint it with fluid acrylics and colored pencils and use it as a cover for a handmade book.
* Cut it into smaller squares and attach it to adhesive craft foam to create texture stamps.
* To use the printing plates that have uneven surfaces, place the plate underneath printing surface and rub uneven areas with the bottom of a spoon or drag a plastic hotel room key over the top. This will help transfer the print to the fabric or paper.

Visit artistsnetwork.com/printmakingunleashed for free bonus printmaking projects

Texture Plate Rubbings

Now that you have created a number of texture plates and tools, use them to add expressive marks to a canvas. Experiment using media like oil pastels and crayons to create rubbings and encaustic techniques for a variation. In this exercise, use toothpick texture plates, a molding paste plate and chipboard stamps to create unique and colorful results.

handmade toothpick and molding paste texture plates

super muslin

oil pastels and paint sticks

water-soluble crayons

chipboard stamps

molding paste collagraph

plastic needlepoint canvas stencils

plastic hair rollers

1 Color Fabric
Place a toothpick texture plate underneath a piece of muslin. Color over the top of plate using oil pastels to transfer the design to the fabric.

2 Add Another Printing Plate
Place another found tool texture plate underneath the fabric and color with more oil pastels and water-soluble crayons.

3 Move Plate
Add more lines around the fabric by moving the printing plate around and adding more color with the crayons.

4 Wood Plate Rubbings
Place molding paste plates underneath the fabric and rub over the top with oil pastels. Move it around underneath the fabric to repeat the design throughout.

5 Accent With Paint Stick
Place plastic needlepoint canvas underneath the fabric and color over the top with an oil paint stick. This stick has an extremely creamy texture and is solidified oil paint which will take a few days to dry completely.

6 Fill In Design
Continue more mark making with texture tools to cover the entire piece of fabric. The pink marks on the left were made by rubbing oil pastels and crayons over plastic hair rollers placed beneath the fabric.

Balloons and Dart Splatter Painting

Freeform splatters of paint are the result of this fun and messy technique. Fill balloons with a little fluid paint and pop them using darts to create painted backgrounds with drips and explosions of color.

liquid watercolors, fluid acrylics or spray inks

plastic cups

balloons

plastic syringe for painting

mixed-media paper

Masonite or foam core board

darts

push pins

1 Fill Balloons With Paint
Place fluid paint in a small plastic cup and use a plastic syringe to draw out the paint. Set aside and blow up balloons. Holding them tight in your hand, place the tip of the syringe into a balloon and fill it slowly with paint, then tie off the top with a knot.

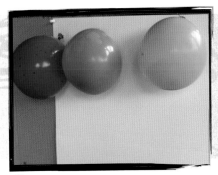

2 Hang Balloons
Pin up a piece of heavyweight mixed-media paper on a Masonite board or foam core outside. Once the balloons are filled, press push pins through the balloon knots to secure them over the paper.

3 Throw Darts
Stand back about 5 feet (1.5m) from the balloons and throw darts to pop the balloons. It helps to wear clothes you don't mind getting paint on.

Balloon Splatter Tips

* It may be helpful to blow up the balloons with a pump or have another person help. One can blow up balloons, and the other can add the paint.
* Always blow up the balloon *before* adding paint.
* Do not use any cadmium paints or others with warning labels that say they should not be sprayed.
* This project is recommended for adults only, or kids supervised by adults.
* This is a painting exercise best done outdoors. If done indoors, make sure to cover floors and walls before beginning.

4 Rotate Canvas
Rotate the background paper, tack up a couple more balloons and repeat throwing darts until all the balloons are popped. The final piece reveals colorful and fun paint explosions.

Encaustic Monoprints

Another option to create texture rubbings is with melted encaustic paint. In this exercise I use Enkaustikos Hot Sticks and a large aluminum plate that is heated by a box of lights. Alternatively, you can put an aluminum plate on a pancake griddle.

encaustic wax stick

grill thermometer

hot glue textured plate

recycled sketch paper

handmade found tool plates

natural hairbrush

anodized aluminum plate

printmaking barren

foam stamps

1 Paint Circles
Heat up an aluminum plate to 150°F (66°C), then draw on it with an encaustic wax stick. Lay a piece of sketch paper on the hot plate. Dip a paintbrush into the melted paint and brush a few circles onto the sketch paper.

2 Toothpick Texture
Place handmade toothpick printing plate underneath the paper and rub a wax stick over the top. This will bring the texture of the toothpicks through onto the front of the paper.

3 Prepare Plate
To print the texture on the paper, melt the top of the wax stick on the hot aluminum plate, then rub it onto the top of the toothpick printing plate.

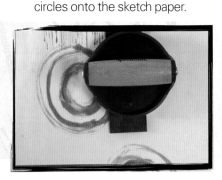

4 Toothpick Print
Turn over the toothpick printing plate onto sketch paper and transfer the encaustic paint to the surface using a barren. Repeat on the top of the page a few times.

5 Rubbing Texture
Place a hot glue cardboard plate under the paper and rub the top with wax sticks to reveal the texture from the cardboard plate.

6 Doodle on Hot Plate
Lift sketch paper from surface, then draw circle designs directly on hot aluminum plate using a wax stick.

7 Transfer Print
Turn the front of the paper over onto the melted encaustic paint to pick up the print. Burnish the back of the paper with a print-making barren. This will help transfer the print.

8 Print Revealed
Pull back to reveal the printed texture.

9 Melt Paint
Repeat. Doodle circles with the wax sticks by drawing directly on the plate.

10 Print on Back
This time place the painted paper face up and press the paper onto the melted paint to pick it up off the hot plate.

11 Stamp Designs
Melt more paint on the hot plate and press the stamp into the melted paint, then stamp the pattern onto the top of the page.

12 Paint More Circles
Add more painted circles using the melted encaustic paint. This is the final print.

Rolled Cardboard Stamps

Recycled cardboard has so many uses in my art. It's been a background for my handmade art journal covers, I've created a Christmas tree from recycled shipping boxes and handmade cards with small remnants. It also makes a great material for stamping. In this exercise, you'll cut strips of cardboard to form rolled stamps.

rotary paper trimmer

recycled cardboard cut into ½" (13mm) strips

scissors

dry adhesive line

1 Cardboard Strips
Using a rotary paper trimmer, cut a piece of recycled cardboard into ½" (13mm) strips by 10" to 12"(25cm to 30cm) in length. Cut against the grain of the cardboard. This will make it easier to bend the cardboard in circular shapes.

2 Curl Strips
Hold one end of the cardboard strip between your thumb and forefinger and then run your other hand across the entire length of the piece to make it more flexible. This will add a curl to the cardboard, similar to the way you would curl ribbons with scissors. This makes it easy to bend and roll the cardboard.

3 Form Shapes
Begin to form shapes by rolling the cardboard strips into circles. Start at one end and roll tightly to form the end of the cardboard into a circle. Place a piece of dry adhesive line in the center of the cardboard to secure it in place. Add another strip of cardboard in between the center of the rolled cardboard, then attach it with a piece of dry adhesive.

4 Add Strips
Tuck another strip inside where the previous circle ends and secure it with another piece of dry adhesive line.

5 Connect Pieces
Roll the end tightly to form a small circle and bend it around to the right to form a loop. Secure it with another piece of dry adhesive.

6 Freeform Shapes
Repeat the last step. Continue to roll and bend pieces to create a freeform shape. This process is very free flowing; there is no plan. Keep securing the cardboard strips as you go until you are satisfied with the shapes.

7 Finish Cardboard Stamp
Wrap the last strip of cardboard around to the right and secure it with dry adhesive. Use this technique for a variety of shapes including pieces of flower petals, circles and leaves. These can be used as stamps and stencils.

BONUS DEMO!

Visit artistsnetwork.com/printmakingunleashed for a free bonus demo on how to print with cardboard stamps to make acrylic skins that can be used in collage.

Clay Relief Plates

Craft supplies can also double as a printing material. Crayola Model Magic is a kids' art supply that is great for creating printing plates. It does not dry hard and can be used for stamping. In this exercise, create a relief printing plate using stamps and Model Magic.

modeling compound

deli paper

soft rubber brayer

rubber stamps

chipboard letter stamp

1 Create Plate
Roll out the Model Magic onto a piece of deli paper using a soft rubber brayer. Make sure it is flat and even in thickness. Press a rubber stamp into the surface and roll on the back of the stamp with the brayer.

2 Add Designs
Choose a few more stamps and repeat the process. Press the stamps into the surface of the Model Magic.

3 Add Letters
Place a chipboard letter stamp into the surface to add letters to the plate. Roll over the back of the chipboard plate with the brayer.

4 Relief Printing Plate
Here's the final plate. Set it aside to dry, depending on the climate it will take up to 24 hours to dry.

Modeling Compound Tips and Ideas

* It's helpful to have a cushion surface when printing with the clay relief plates. Place a paper or board substrate on top of a folded towel or fabric. This will help create more detailed prints.
* Experiment with molding or fiber paste for printing more textured surfaces.
* Create smaller modeling compound stamped plates to use as journal embellishments.

Clay Relief Plate Background Paintings

Here's a simple exercise to create a painted background using the relief stamp plate. Mix multiple colors of Golden High Flow acrylics and print the relief stamp to create a patterned background. This is a great technique for creating an art journal page background.

High Flow acrylics

modeling compound relief stamp plate

soft rubber brayer

1-inch (25mm) foam brush

clayboard

1 Apply Paint
Brush on High Flow acrylics, mixing two colors to create bright orange. Work quickly so the paint does not dry out on the printing plate.

2 Print Stamp
Place the printing plate face down onto the clayboard and roll over the back of the stamp with a brayer to transfer the print to the surface.

3 Add White
To change the color of the print, add High Flow white acrylic paint with a foam brush and repeat the printing process in step 2.

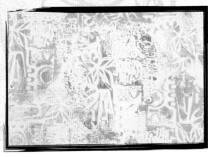

4 Fill Page
Repeat the printing process until the page is full of prints. Turn the stamp in different directions while printing to get different parts of the stamp on the page. Set aside to dry.

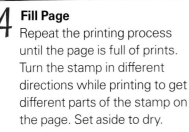

5 Wash Page
Add water to the brush and wash over the top of the painting to fill in white space.

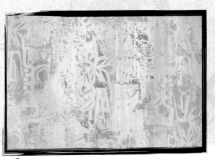

6 Color Wash
Finish filling in the background by adding a little color to the brush and water.

Clay Stamps

Modeling compound is lightweight and there are many ways to mold and shape it into DIY stamps and texture plates. It dries to a spongy, slightly flexible consistency which is perfect for stamping and printmaking. Experiment creating your own printing plates and stamps!

modeling compound

soft rubber brayer

comb

deli paper

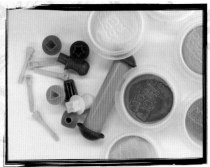

1 Gather Tools
Make a variety of printing plates out of modeling compound. In this exercise I used Crayola Model Magic Presto Dots and a variety of plastic texture tools to draw into the surface and cut out shapes.

2 Mix Colors
Select a bit of two colors of modeling compound and mix into a ball by kneading it with your hands. I chose pink and white.

3 Roll and Punch
Place a brayer in the middle of the ball and roll back and forth until the compound flattens to ¼-inch (6mm) thick. Roll out into a smooth even plate. Use a small circle texture item to punch circles out of the modeling compound. Smooth out a second plate. Here I used green.

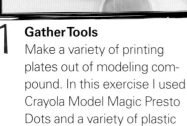

4 Make Stamp
Place the cut-out circles from the first plate onto the second plate. Secure them to the surface.

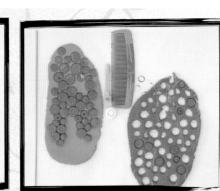

5 Add Texture
Continue to fill the second plates with dots from the first plate. Use tools like the bottom of a skewer or comb and press them into the compound to create textures.

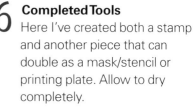

6 Completed Tools
Here I've created both a stamp and another piece that can double as a mask/stencil or printing plate. Allow to dry completely.

Dimensional Paint Decals

Adding dimension to paintings creates interesting textures in artwork. I've been creating decals for years. I first experimented with them to decorate holiday ornaments. I love to use dimensional paint to create decals that I can use as embellishments. Draw with the paint straight from the bottle or tube onto a release surface. When it's dry, peel it from the paper and collage it into mixed-media paintings, clothing, handbags and art journals.

Teflon or gallon freezer bag

High Flow, fluid and dimensional paint

Collage Pauge glossy in a fine tip applicator bottle

glitter

trowel palette knife

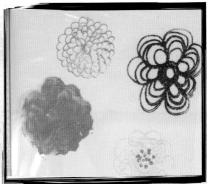

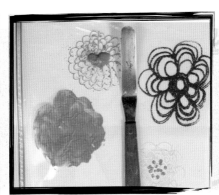

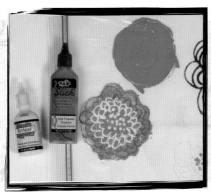

1 Doodle on Bag
Draw flower shapes onto plastic freezer bags with dimensional paint and Collage Pauge glossy mixed in a fine tip applicator bottle. While wet, sprinkle glitter over the mediums. Mix fluid pink with molding paste and spread it onto the bag in a flower shape. Set aside to dry.

2 Paint Layer
Squeeze a little fluid acrylic onto the doodled flower and spread it out with a palette knife until it covers the entire flower.

3 Dimensional Doodles
Draw flower designs with two colors of dimensional paint. See example of pink flower on page 112.

4 Mix Medium
Use a palette knife to mix Collage Pauge glossy with fluid acrylic paint. Then apply a thin layer of the mixture over one of the flower doodles.

5 Decals
After the paint is dry, carefully peel them off of the plastic bag and apply them onto the surface of your artwork.

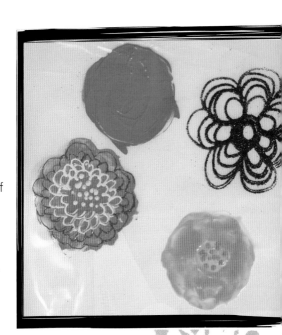

Visit artistsnetwork.com/printmakingunleashed for free bonus printmaking projects

Clay Plate Printing Techniques

Now that you've created the printing plates, it's time to experiment with using them. They can be used as stamps, stencils/masks or run through an embossing machine like the encaustic plates. Here are two simple ways to use your modeling compound plates. Combine them for creative results!

modeling compound plates

soft rubber brayer

1-inch (25mm) foam brush

fluid acrylic paint

plastic paint palette

gessobord

1 Ink Plate

Place fluid acrylic paint on a palette and dip a foam brush into it. Brush paint onto a Model Magic plate.

2 Print Plate

Turn the painted plate over onto the gessobord panel and use a soft rubber brayer to roll over the back to transfer the print to the surface.

3 Ghost Prints

Print the stamp multiple times until all the paint is transferred from the plate.

4 Brush on Paint

Use the same brush; don't rinse it out to avoid getting excess water in the paint. Choose a color that will blend with the first and apply the color onto a different plate using a foam brush.

5 Print Plate

Place the painted plate face down on another area of the board and repeat the printing process using the brayer.

6 Reveal Print and Repeat

Pull up the printing plate and to see the image on the surface. Repeat, adding paint to the plates and stamp multiple times to create patterns on the board.

7 Final Print

This makes a great background on the board. Now you can paint a wash and continue to paint layers over the top of the pattern.

Fiber Paste Leaf Decal

This decal was made using fiber paste and dimensional paint, a variation of the technique on page 47. In this exercise mix paints and fiber paste to create a leaf decal. The decals can be used as dimensional collage elements or to create textures in your mixed-media paintings.

gallon-size plastic freezer bag

fiber paste

fluid acrylic paint

towel palette knife

small flat paintbrush

dimensional paints

1 Mix Paste
Place a dollop of fiber paste onto a freezer bag and add a few drops of fluid acrylics. Mix with a palette knife and apply the mixture onto the bag in a leaf shape. Use the edge of a palette knife to draw designs into the fiber paste.

2 Smooth Texture
Use a brush to even out the surface of the fiber paste mixture. Creating an even layer will help it not fall apart when removing it from the plastic. Set aside to dry.

3 Outline
Add detailed lines to outline the leaf shape with dimensional paint or puffy paint. Once it dries completely, peel it off carefully. Use the dried leaf decal as a collage element in one of your mixed-media paintings.

Dimensional Paint Decals in Action
I painted this piece for a special event. It's a section of a gown I designed with hand-dyed fabric, free-motion stitched painted fabric and embellished with dimensional paint decals.

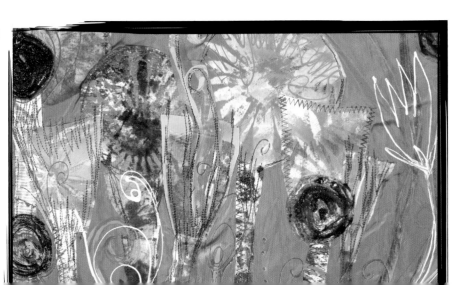

Doodle Paint Plates

Another way to recycle cardboard is to paint it by doodling with the tube or bottle. No brushes needed! Experiment with dimensional paint or paint tubes and draw right onto the surface of the cardboard. Etch into the designs with skewers or other mark-making tools. Let dry, then use it as a texture for rubbings, or cut the doodle painted cardboard to create a textured stamp.

recycled cardboard

dimensional paint

scissors

adhesive craft foam

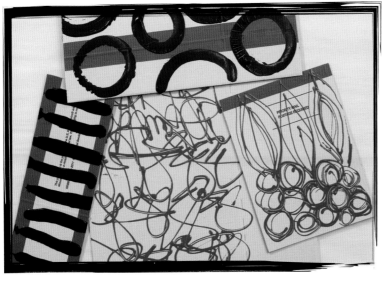

Doodle paint printing plates.

1 Graffiti Doodles
Scribble words or write quotes on a piece of recycled cardboard using dimensional paint. Place the tip of the bottle to the surface while simultaneously squeezing the bottle with light pressure to produce thin, even lines of color. Work fast across to avoid big blobs of paint. Cut triangle shapes from the doodled cardboard.

2 Create Printing Plate
Adhere shapes onto adhesive craft foam.

3 Add Shapes
Continue to fill in the craft foam with triangle shapes, placing them in a random fashion. Place a few shapes to the edge of the stamp so the image bleeds to the end.

Visit artistsnetwork.com/printmakingunleashed for free bonus printmaking projects

Plastic Freezer Bag Masks

Plastic resealable bags aren't only for storing your leftover food. They make great printmaking materials such as stencils and masks. The great thing about them is that after they are sprayed with inks, the ink stays wet on the plastic and monoprints can be taken of the leftover paint. Have fun creating multiple prints quickly using this easy technique.

gallon-sized freezer bag

scissors

drawing paper

fluid acrylic paint and spray inks

soft rubber brayer

deli and construction paper

1 Cut and Spray Stencils
Cut apart a freezer bag into large squares or rectangles that will fit over printing paper. Create symmetrical masks by folding the pieces of plastic in half, then cutting out half of the stencil shapes. I chose to cut flowers and leaves. Place stencils over paper, then spray with inks.

2 Create Mirror Print
Place a second piece of drawing paper over the first sheet while the ink is still wet on the stencils. Roll over the back of the paper with a brayer or your hands. Pull apart the paper to reveal the print.

3 Place Stencils Over Middle
Place stencils over the middle of the two pages, then spray with yellow ink. Leave the stencils in place for the next step.

4 Take Ghost Print
Before you remove the stencil masks, place another piece of construction paper over the sprayed stencils and rub to transfer the ink to the page. Reveal the print (shown here print side up) and let dry.

5 Print Reveal
After the masks are removed, here is the print. While this is drying, continue to make more prints and build layers on the pages.

6 Add Layers
Place stencils on the ghost print from step 4, then spray ink and take another print with a different piece of paper (here, the green construction paper).

7 Brayer Prints
Roll out fluid acrylic paint on a piece of deli paper palette. Place freezer bag masks onto the painted background. Ink your brayer on the deli paper and roll over the mask. Repeat this with both the positive and negative flower shapes.

8 Printed Layers
While the plastic bag masks are still wet, turn them over and use them as printing plates. Place them over the original first series of flower prints and roll over the back of the stencil masks using a clean, soft rubber brayer.

9 Multiple Prints
Work fast and build layers on the pages with contrasting colors.

Deconstructed Paper Printing Plates

Create printing plates from everyday items like recycled paper. Use up all those odds and ends sitting around your studio. This technique starts with layering sheets of textured paper, torn cardboard and newsprint that is held together with free-motion stitching. Then the stitched paper is deconstructed by cutting into smaller shapes and adhered to a base to create a textured stamp and printing plate.

recycled cardboard

recycled paper such as binder, graph, rice, mulberry, newspaper and packing chipboard

sewing machine and thread

scissors

adhesive craft foam

1 Gather and Stack Paper

Gather recycled paper, cardboard or anything with texture. Crumple some of the thinner paper to add texture, then flatten them out.

Create layers by placing various papers on top of each other. They don't have to be the same size but it's easier to sew if they are similar in length. Place the paper staggered with strips of corrugate cardboard over the top.

2 Free-Motion Stitch

Start at one end of the stack and sew with a machine to secure the papers together. Add stitched designs, lines and zigzags.

3 Cut Apart

Use scissors to cut in between stitched lines through all the layers of paper.

4 Deconstructed Paper

Once the paper is cut, fan out the edges. This will create more textured areas in the paper. These pieces will be used to create a printing plate.

5 Cut Shapes
Cut square and rectangle shapes in different sizes from the deconstructed paper strips.

6 Printing Plate
Begin to assemble a printing plate by placing cut paper squares onto the sticky side of a piece of adhesive craft foam. Continue to place all the paper shapes until the craft foam is full.

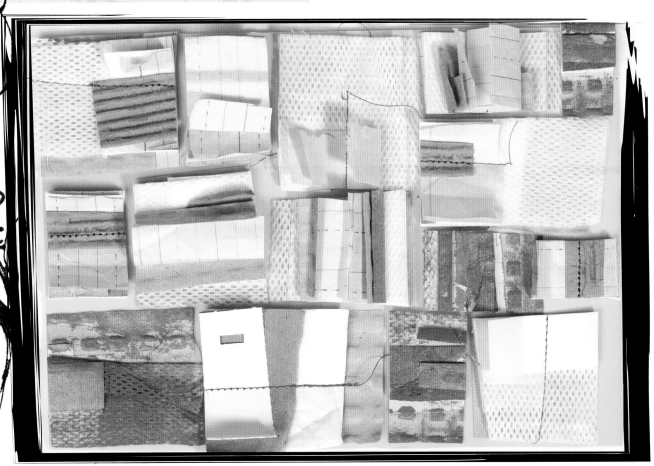

Paper Printing Plate Tips and Ideas

* The amount of paper used to create the stack depends on the thickness of the paper and how much your sewing machine can handle. Consult your sewing machine manual for guides to material limitations.
* Experiment with adding a variety of thread and raffia to the plate by couching it on the surface.
* For a variation on this technique use dyed fabric and interfacing. Cut it apart and create a journal cover.
* Instead of using adhesive backed craft foam, glue the pieces onto a piece of mixed-media board or cardboard to create an art journal cover.
* Cut the stitched pieces into shapes. Paint the edges with glue and sprinkle glitter to create a collage embellishment.

Paper Printing Plates in Action

Create colorful layered paintings using the deconstructed paper printing plate from the previous exercise. This plate has dual uses: as a texture plate underneath the surface to burnish the design or use it as a stamp to create interesting textured square patterned layers.

fluid and OPEN acrylic paint

deli paper palette

soft rubber brayer

1-inch (25mm) foam brush

spray bottle filled with water

deconstructed printing plate

gesso

1 Roll Out Paint
Place some OPEN acrylic paint on a deli paper palette and roll it out to cover the brayer with paint. Place the deconstructed printing plate under a piece of drawing paper.

2 Transfer Print
Roll a painted brayer over the top of the drawing paper. This will create a painting that picks up the texture from the plate on the surface of the paper.

3 Multiple Layers
Add a few drops of bronze OPEN acrylic paint and roll the paint with a brayer. Move the printing plate to different areas while making prints and turn the paper a few times until you are satisfied with the first layer. Set aside to dry.

4 Print Plate
Apply more paint onto the plate using a foam brush. Since loose paper can be very delicate, apply the paint in a soft dabbing motion. Place another piece of drawing paper face down on the painted plate. Rub the back of the paper with your hands to transfer the print.

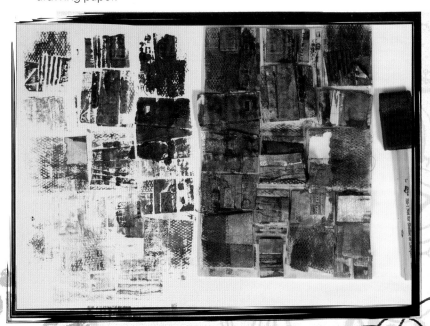

5 Add Water

Spray a mist from the water bottle onto the inked plate. This will mix with the paint and reactivate it. Place the painted paper onto the wet surface to transfer the print. This will result in a lighter, almost water-color-like transparent print.

6 Gesso Prints

Dip the foam brush into gesso and apply it onto small areas over the painting. Press the printing plate into the wet gesso. This will create a tinted print of the plate on the paper. Repeat in different areas around the page.

7 Tinted Prints

Don't wash out the foam brush. Dip it into white paint. This will mix with the color on the brush and create a tint. Brush the paint onto the top of the plate. Keep the plate on the table. Pick up the print from step 3 and turn the painted side of the paper face down onto the plate. Rub the back of the paper with your hands to transfer the print.

8 Deconstructed Prints

Here are two different prints created by using the plate as a printing and texture tool.

Paper Plate Tips and Ideas

* Some paper will end up collaged onto the surface of the print, which creates interesting textures.
* Once the pages are dry add a contrasting paint wash to fill in white space.
* Use your hands or a barren to rub the paper and work the design into all the crevices on the printing plate.
* Experiment using fabric as the substrate for this technique. Thinner fabrics with less weave work better for crisp images. Woven fabrics or those with a lot of texture will not transfer prints as well.

Color Palettes

Colorful palettes make their way into all aspects of my art, in my journals, inspiration books and throughout my studio. At the end of each section in the book, you'll find ideas and photos of ways to create different color palettes and some of my favorite color combinations.

Use photos to create color palette swatches. I like Photoshop and the colourlovers.com online tool and smartphone app where you can pull colors from your photos to create palettes. Use the colors to inspire your art journal backgrounds or paint colors.

Cut swatches of your paintings and tape them in your journal or to the wall to create a color inspiration board. Paint flowers and washes with watercolor paint inspired by the color palette.

A color palette of tangerine, turquoise, bronze and sunflower in acrylic paint, colored pencil and oil pastel on muslin.

Use the shapes and colors of the seasons to create stamps and patterns on tissue paper. This color palette is inspired by fall leaves.

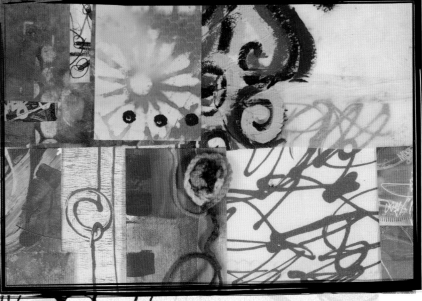

Cut swatches from your various monoprints and painted backgrounds to create a color palette.

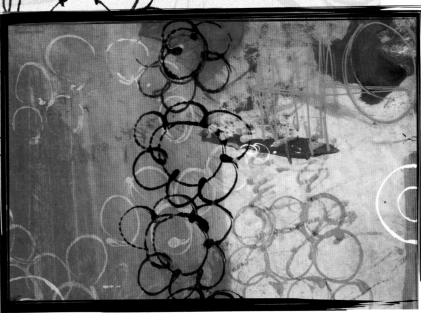

Paint doodles and monoprint flowers in circles on deli paper. This color palette is made up of dimensional paint monoprints and scribbles with prints from stamps and cookie cutters.

Visit artistsnetwork.com/printmakingunleashed for free bonus printmaking projects

part 2

Printmaking Techniques

For years, I've been using Plexiglas for most of my monotype printmaking. It's an inexpensive substrate, is easily accessible and makes a great surface to create prints without a press. I've also used plastic gallon bags, page protectors, freezer paper, transparencies, Dura-Lar and parchment paper, but my favorite to work with is Plexi. The techniques I share are starting points for exploration and Plexi can be interchanged with any of the materials mentioned above. My methods are all about play and experimenting—building layers on multiple pages fast so no two paintings look exactly the same.

In this section, we will combine the unique tools from part one with digital and traditional printmaking techniques to produce one-of-a-kind monoprints. We'll start with the basics and work our way through the various techniques I use to create my layered paintings. We'll practice building colorful layers, using subtractive methods to wipe away paint, scribbling with skewers, creating translucent acrylic skins, pulling prints and much, much more. Let's get ready to play and print!

Translucent Acrylic Skins

When acrylic paint is mixed with Collage Pauge and allowed to dry, it forms a thin, pliable layer that is perfect for layering in collage and paintings. You can make skins with a variety of colors or mix them with glitter and mica to create unique designs. Or press them with handmade stamps to create cool textures and use them as a base for digital printing. The possibilities are endless! Here is the basic technique for creating a skin.

Collage Pauge matte

plastic page protector

trowel palette knife

soft rubber brayer

High Flow acrylics

drawing paper

foam brush

1 Mix Medium
Pour Collage Pauge matte and a few drops of High Flow acrylic paint onto a plastic page protector and mix with a palette knife directly on the surface.

2 Draw Circles
Use a brayer to roll out the paint. While the base color is still wet, draw circles with the tip of the bottle of darker High Flow acrylic paint colors. Add circles with white paint and teal blue, allowing the colors to overlap so they will blend.

3 Add Paint
Draw more circles using High Flow fluorescent pink. Make sure the tip of a bottle touches the surface. Set aside to dry.

Acrylic Skins Tips and Ideas

* Acrylic skins can be made out of a variety of acrylic-based paints, mediums and inks. Experiment!
* I choose to mix my paints with Collage Pauge matte because it dries less sticky than gloss medium and the paint straight from the bottle.
* Instead of a plastic page protector, you can alternatively use freezer paper, parchment paper, Teflon sheets, HDPE (high-density polyethylene) Plexiglas sheets or garbage bags as a base. All of these will release the acrylic mixtures once they dry.
* Build texture into the skins using stamps, stencils and other mark-making tools.
* Use the skins as printmaking surfaces when printing with Plexiglas, or experiment using them in fabric collage, over black-and-white images or as an art journal page.

Technique
Graffiti Acrylic Skins

<< *Creative Toolbox*

Personalize your acrylic skins with a favorite quote or mantra by adding marks and letters with dimensional paint beneath the transparent paint layers.

plastic page protector

dimensional paint

Collage Pauge matte

fluid acrylic paint

ultra fine glitter

trowel palette knife

1 Write Words
On a plastic page protector, write words or draw doodles with dimensional paint. Set aside to dry.

2 Create Color
Pour Collage Pauge matte, fluid acrylic paint (Quinacridone Magenta and Micaceous Iron Oxide) and glitter directly onto the center of the page.

3 Mix Color
Mix the mediums and paint together using a palette knife.

4 Cover Page
Spread the mixture in an even layer over the top with the palette knife. Allow to dry and store on plastic page protectors in a binder.

Stencil Resist Skins

It's fun to experiment with building unique translucent layers of paint. In this exercise, use a plastic page protector as the base to build up layers, then make cool prints from hand-cut stencils and masks. Mix with Collage Pauge to create a unique skin.

1 Stamp Some Flowers
Press stencils wet with paint onto the page protector surface and roll over them with a soft rubber brayer to transfer the print. Set aside to dry. Pour a few drops of fluid acrylic paint.

2 Spread Paint
Roll out the paint over the entire surface with a soft rubber brayer.

3 Press On Flower Stencils
Place hand-cut flower stencils over the wet paint. Take a new plastic page protector and press it against the base layer creating a sandwich of two page protectors. Rub the top layer with your hands. Scribble onto the top with the end of a paintbrush. Slowly lift the top page protector from the bottom layer and set aside.

4 Take Two Resist Prints
Press a piece of paper over the painted stencils from step 3, smooth with your hands and carefully pull to create a resist print. Set aside to dry. Repeat this once more while the paint is still wet.

5 Add More Paint
Roll more paint out over the stencils using a brayer.

6 Pull a Print
Place a piece of blueprint or drawing paper over the top, rub the back and pull another print.

7 Remove Stencils
Remove the two flower stencils from step 3, then add one to the center.

8 Spread Paint
Mix some Collage Pauge matte with a few drops of hot pink fluid acrylics and spread over the entire surface covering the third flower stencil. Set aside to dry.

9 Peel Flower
Carefully remove the flower stencil in the middle. Pour a little Collage Pauge matte and fluid acrylic paint onto the surface.

10 Cover Surface
Mix the medium and paint thoroughly. Use a palette knife to spread in an even layer across the surface. Allow the finished skin to dry completely.

Fusion-Dyed Collage Skins

In this exercise we will build a collage on a plastic sheet with previously dyed paper towels and fuse them with an iron and parchment paper. The results can be used in a variety of ways including art journal covers, handmade greeting cards, collage pieces or as a substrate for digital printing.

Collage Pauge matte

plastic page protector

trowel palette knife

dyed paper towel prints

foam brush

iron and parchment paper

1 Collage Paper
Brush a layer of Collage Pauge matte onto a plastic page protector. Place a piece of dyed paper towel on the medium and brush another layer of Collage Pauge over the paper towel to seal it. Smooth out the paper with your fingers to remove any air bubbles.

2 Add Layers
Cover the other half of the background with Collage Pauge using a foam brush. Overlap another printed paper towel on the previous collage paper. Drizzle more Collage Pauge over the top.

3 Cover Collage
Spread Collage Pauge over the top of the collage with the foam brush. Again check for air bubbles and smooth out with your fingers. Set aside to dry.

4 Smooth and Peel Collage
If the collage has a heavy texture, iron it to smooth it out. Peel the collage from the plastic backing and place it between two pieces of parchment paper. Iron using a medium setting to press out the texture.

Monoprints With Translucent Skins

I love to create simple paper monoprints by drizzling paint onto a piece of paper and pressing onto another piece of paper to make a print. In this exercise, we use the same technique but instead use two plastic page protectors as base substrates.

Collage Pauge matte

High Flow acrylics and glitter

plastic page protector

1 Mix Medium and Draw Circles
Drizzle Collage Pauge matte and High Flow acrylic paint onto a page protector. Roll out the mixture with a soft rubber brayer. Place the tip of a High Flow acrylic bottle directly on the wet paint and draw circles and shapes.

2 Press and Lift Print
Place another plastic page protector on top of the wet paint and rub lightly around the surface tracing the circles with your fingers. Press harder with your finger to draw circles and scribble fun designs in the paint. Slowly lift the edge of the top plastic layer from one corner to reveal the print.

3 Drizzle Paint
Drizzle white High Flow acrylic onto the wet paint of one of the painted backgrounds.

4 Doodle Circles
Draw designs with the tip of the paint bottle. The paint will begin to mix. Sprinkle a little glitter around the painted background. When dry, peel the skin gently from the backing. Cut it and collage it into the painting.

Visit artistsnetwork.com/printmakingunleashed for free bonus printmaking projects

Printing on Collage Pauge Skins

Collage Pauge matte medium makes a great surface to print directly on with an inkjet printer. Whether it's a layer of Collage Pauge on a plastic page protector or over a fusion-dyed collage, it holds the ink permanently without any extra prep. This technique allows you to print images, digital scans or layers of paintings and transparencies directly onto a thin clear acrylic skin.

Collage Pauge matte

plastic page protector

trowel palette knife

scissors

painter's tape

artwork or image to print

inkjet printer, paper and ink

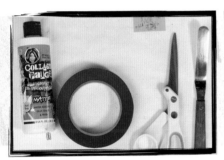

1 Create a Plain Skin
Create a plain Collage Pauge skin by drizzling Collage Pauge matte onto a plastic page protector. Spread it out evenly over the surface using a palette knife. Set aside to dry.

2 Prep the Paper
Cut the page protector down the fold and around the edge. The Collage Pauge skin remains stuck to the front piece of plastic. Cut the plastic a little smaller than 8" × 11" (20cm × 28cm) so it will fit onto the carrier paper. Tape down two sides of the plastic with painter's tape onto a piece of inkjet paper. Making sure the Collage Pauge side is facing up, feed the carrier sheet that holds the skin through the printer.

3 Print or Scan Artwork
If you have an all-in-one printer, you can either print an image from the computer or use the copy function to scan and print the art to the skin. Place the layered artwork onto the glass and close the lid. Place the taped Collage Pauge skin into the feeder and press copy.

4 Printed Skin
After the print has dried, remove the tape and peel up the acrylic skin from one edge slowly, making sure not to tear it. You will have a beautiful transparent printed skin that can be used for collage and in your paintings.

Tips for Printing on Acrylic Skins

* This technique is only for inkjet printers and works best with permanent inks.
* It is best to use a printer that feeds from the back to allow the paper to run through the printer without having to bend too much.
* Running alternative substrates through a printer voids the warranty, so I have an inexpensive inkjet printer I use strictly for my digital printing over painting.
* Temporary spray adhesive can be substituted for the painter's tape on thin paper.
* If the ink from your printer smears, use Golden Digital Grounds as an alternative to cover the surface of the skin. Follow the directions on the bottle for best results.
* Make sure all paint and medium is completely dry before putting it through the printer. Drying time will vary depending on printer and climate.

Printing on Fusion-Dyed Collage Skins << Creative Toolbox

Use one of the fusion-dyed collage skins you created (see page 68) and print a black-and-white image over the top.

1 Create Collage
Collage various dyed paper towels onto a plastic page protector using Collage Pauge matte using the technique on page 68. Set aside to dry.

2 Black-and-White Design
Create black-and-white illustrations, doodles or line art on printer paper using black permanent markers and pens. In this example I'm using photocopies of doodles from my journal.

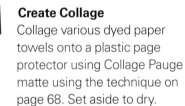

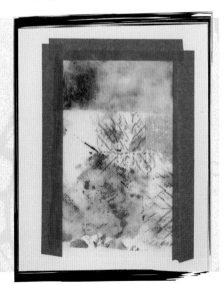

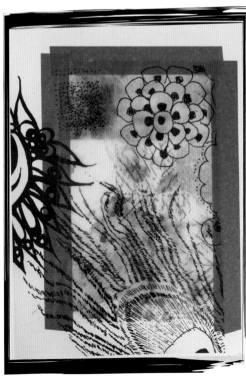

4 Print Design
Place the black-and-white drawing over glass on an inkjet printer bed and press copy. Alternatively, print an image from the computer. Set printed image aside to dry.

3 Prepare Substrate
Tape three sides of the collage onto a piece of inkjet paper. For thicker bases of collage and textures, tape three sides instead of two.

Fusible Painted Prints on Fabric

Make a layered painting by transferring designs on fabric with iron-on adhesive. In this exercise you'll create painted layers and doodles pressed into fabric. It creates a satin finish on the fabric and is great for mixed-media art quilting techniques.

- heat-activated adhesive
- foam brush
- fabric paint
- dimensional paint
- drill cloth fabric
- permanent or fabric markers
- iron
- parchment paper
- fluid and High Flow acrylic paints
- white correction pen

1 Paint Adhesive
Brush a couple of colors of paint onto a piece of heat-activated adhesive (I prefer HeatnBond Lite) using a foam brush. Draw designs on top with dimensional paint.

2 Doodle Flowers
Draw on a piece of drill cloth fabric using permanent or fabric markers.

3 Transfer Paint
Place the painted adhesive face down on the drill fabric and cover with a piece of parchment paper (I use Reynolds brand). Iron using medium heat until the adhesive is set and the backing paper peels off easily.

4 Print Reveal
Here's the first layer of paint on the canvas.

5 Draw Designs
Paint fabric paint onto a piece of heat-activated adhesive. Draw with the tip of a High Flow acrylic bottle to create circular designs. Draw even more circles with dimensional paint.

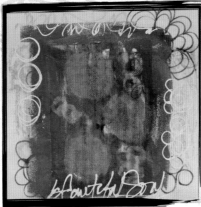

6 Transfer Design
Place the painted design onto the first layer from step 4, cover with parchment and iron on a medium setting.

7 Fused Design
Peel back the release paper to reveal the design. If you wait until it cools completely and then peel, the image will be shiny. If you peel while it's still warm, the image will be satin.

8 Add White
Draw with the tip of the High Flow acrylic paint bottle and write a few words with a white correction pen.

9 Add Dimension
Doodle some more designs with dimensional paint. Keep the tip touching the surface, and squeeze the bottle gently as you write and doodle to create a clean, thin line. Allow to dry. This piece of artwork would make a great art journal cover!

Technique
Digital Photography Stencils

Photography is a big part of my art. I carry my smartphone everywhere and take inspirational photos during my walks, shopping excursions and while I'm creating art. Use these daily snapshots to create one-of-a-kind stencils for your mixed-media creations. In this exercise, we use Photoshop to create unique stencils from our digital photos!

1 Black-and-White Photos
Alter a color photograph using Photoshop or your favorite image editing tool (see sidebar). Print the black-and-white photographs onto cardstock using an inkjet printer.

2 Cut Designs
Cut out shapes, lines and designs from the black-and-white printed cardstock. Use a sharp craft knife and cutting mat to create the stencils.

3 Check Designs

Place a piece of colored paper underneath the cut area to help you see the progress of the stencil. Turn over the cut cardstock and place it over a bright colored paper to see the actual shape of the stencil. Continue to cut it down until you achieve the stencils you desire.

Another example of hand-cut photo stencils. Once you've finished cutting your stencils, place them over a piece of fabric or paper and color them with spray inks, paints or soft pastels to create colorful layers on your canvas.

Converting a Digital Image in Photoshop

Using a photo editing software such as Photoshop, it's really easy to alter your digital photos to create high-contrast black-and-white images.

1) Open image in Photoshop. Choose File > Open and choose the image file.

2) Adjust the color to black and white. Choose File > Open and choose the image file you wish to open. Choose Image > Adjustments > Black & White.

3) Make black-and-white. Choose OK. This will change the photo to black and white.

4) Adjust levels. In the Adjustments panel, choose Levels. This will bring up a slider bar.

5) Finish and save. Move the sliders to get the contrast image you like. Here I've moved all three to the center to obtain a sharp black-and-white contrast. Choose File > Save and name your file.

Technique
Digital Layers and Photos

<< Creative Toolbox

variety of acrylic skins, artwork, journal pages, drawings and prints

inkjet printer and paper

cardstock

scanner

Dura-Lar

This is a simple way to repurpose your art by creating photocopy layers. This can be done on a photocopy machine or all-in-one printer. It's a great way to create mash-up art if you don't want to use a photo editing program like Photoshop or iPad apps like ArtRage or Procreate. Artwork layers can be stacked, then copied or printed with one piece of art, then run through the copier again and printed over on another piece of art. There are so many possibilities!

1 Colorful Layers
Gather a variety of artwork on different substrates. Choose pieces with colors that will work together when stacked on top of each other. Here I have a transparency monoprint on Dura-Lar, India ink on bark paper and a page from my art journal.

2 Stack Artwork
Arrange the artwork and prints in interesting layers, place on the copy machine and take a print. Or place them face down on the glass bed of an all-in-one printer and press copy.

3 Artwork Printout
Here's the final printout of the stacked artwork. I use these for collage papers or as pages bound into my handmade books. Experiment with creating your own digital layered prints.

Digital Layers Example 2

1 Select Artwork Layers
Choose black-and-white letters, a painted transparency and circles painted on Dura-Lar.

2 Print Artwork
Stack the artworks on top of each other and photocopy or scan.

Transparency Overlays
Paint on Dura-Lar and layer it over black-and-white artwork or journal pages and create digital images by photocopying, scanning or printing on your inkjet printer.

Visit artistsnetwork.com/printmakingunleashed for free bonus printmaking projects

Digital Layer Ideas

Layer dyed paper towels with graffiti on Dura-Lar.

Flower monoprints on newsprint overprinted with stamped fabric and painted Dura-Lar.

Hot glue stencil print on drill cloth layered with two scribble transparencies.

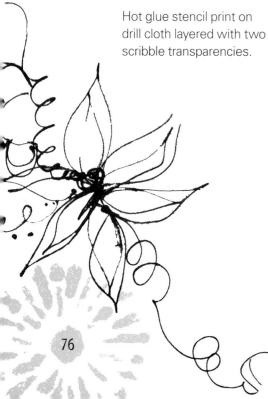

Graffiti journaling canvas printed muslin, hand-cut paper stencil and painted monoprint.

Hot glue stencils scanned and printed on inkjet paper.

Fused plastic painted with acrylic and layered with painted transparency.

Black-and-white artwork overprinted with two prints of artwork.

Visit artistsnetwork.com/printmakingunleashed for free bonus printmaking projects

Basics of Plexiglas Printmaking

These are the basic materials and methods for how I create my layered monotype paintings. In the following exercises, we will work with a Plexiglas sheet as a base and cover it with paints. Experiment with subtractive doodling techniques using a variety of tools and handmade stamps and stencils to pull prints from the Plexi to build colorful layered paintings. Most of my monotype printmaking is done on separate sheets of paper or fabric, then used as collage sheets or bound as pages in my handmade journals.

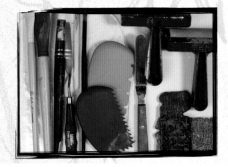

Printmaking Supplies
These are my favorite mark-making tools and materials for Plexiglas printmaking—a variety of brushes, silicone tools, brayers and knives.

Substrates
Papers, fabrics and skins.

Printmaking Colors
Some of my favorite paints and inks for monotypes—fluid and OPEN acrylics, fabric and dimensional paint, coloring brush markers and ink sprays.

Mark-Making Tools
A collection of my handmade stencils, foam stamps, cardboard textures, found objects, paper masks and needlepoint stencils.

Basic Gel Plate
A homemade gel plate is an easy and affordable alternative to printing with a sheet of Plexiglas. Squeeze Collage Pauge glossy onto a plastic page protector in a thick layer. Though it will hold its shape, as it dries it will start to show cracks, so fill them gradually with more Collage Pauge glossy using a plastic hotel room key to scrape the medium into a level surface. Set aside to dry overnight.

Technique
Simple Plexiglas Monoprint

<< Creative Toolbox

11" × 14" (28cm × 36cm) Plexiglas sheet

OPEN acrylic paints

soft rubber brayer

paper

paper stencils

Most of my monotype printing starts with rolling out a layer of paints onto the Plexiglas plate. I start with a couple colors of paint, and typically I don't mix the paint thoroughly because I like to see the variations of color on the print. This base layer of color will be the first layer on the print.

1 Cover Surface
Place one to two dollops of OPEN acrylic paint onto the Plexiglas surface. You can also use the homemade basic gel plate we created on page 78. Use a soft rubber brayer to roll paint across the top of the Plexiglas.

OPEN Acrylics

I recommend using Golden OPEN acrylics for Plexi printmaking. They allow you to work with the paints for a longer period of time without drying out and also clean off the plate more easily.

2 Rolled Out Paint
The surface should be completely covered with paint. Now it's ready to start the monotype process.

3 Clean Brayer
To clean the brayer, roll paint onto a piece of paper to remove the excess paint. Experiment with rolling over paper stencils for added designs. These clean-up papers can be used during the monotype process to add more layers.

Visit artistsnetwork.com/printmakingunleashed for free bonus printmaking projects

Stencils and Masks

Cut simple, symmetrical paper masks or use handmade hot glue stencils to create subtractive areas on the Plexiglas plate.

1 Symmetrical Stencils
Fold a piece of paper in half and cut out half a stencil shape. Place the stencils over a rolled-out paint surface as seen on page 81.

2 Transfer Print
Place a piece of paper over the stencils and burnish the back with a clean, soft rubber brayer. Also use your hands to press around the stencil shapes to assure that the paint transfers to the paper.

3 Pull Print
Carefully pull the paper up from a corner to check if the paint transferred. If you are satisfied with the outcome, pull the paper off the plate.

4 First Print
This is the first stencil resist print. Notice most of the paint has transferred to the paper.

5 **Remove Stencils**
Take the paper stencils off of the plate and set them aside. If they have a lot of paint on them, place them onto another piece of paper and use a brayer to roll over the back of the stencil to transfer the paint. Once the stencils are dry, they can be used again or added as a collage element in a painting.

6 **Print Two**
Place another piece of paper onto the painted plate and carefully peel from one corner of the plate to reveal the print.

7 **Outline Print**
Here is the second print pulled from the plate, which shows the outline of the original stencils and is slightly different from the first impression.

8 **Ghost Print**
While there is still a little wet paint on the plate, spray it with a water bottle, then place another paper and pull a print.

Technique
Ghost Prints

paper stencil shapes

11" × 14" (28cm × 36cm) Plexiglas sheet

OPEN acrylic paint

soft rubber brayer

spray bottle of water

construction paper

The second or third print taken from the plate is what is known as a ghost print because the end result is a much lighter version of the original print. Before you clean off the painted Plexiglas plate, take multiple prints. Use a spray bottle filled with water to help saturate the paint, place the paper and pull each print. The final prints will have a watercolor-like quality.

1 Excess Paint
Place a paper stencil at the edge of the plate. Pick up the rest of the paint on the plate. Press the edge of the previous pulled print onto the plate to overprint the design.

2 Print Reveal
Add layers to previous prints. This shows the print picked up on the edge of the paper.

3 Ghost Print
Now that most of the paint has been transferred in the previous pulls, spray the plate with a light mist of water, then place a previous print over the plate. This will pick up the leftover paint. Place the previous printed paper in the center of the plate, holding up the right side. This will transfer only a portion of the print to the paper.

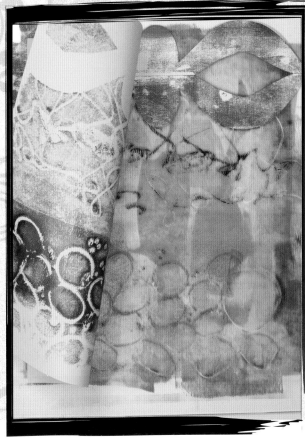

4 Print Reveal
Here is the overprint from the second pulled print.

5 Third Print
Spray another light mist of water over the plate. Place another piece of construction paper onto the wet surface and press the back with your hands.

6 Print Reveal
Here's the ghost print on construction paper.

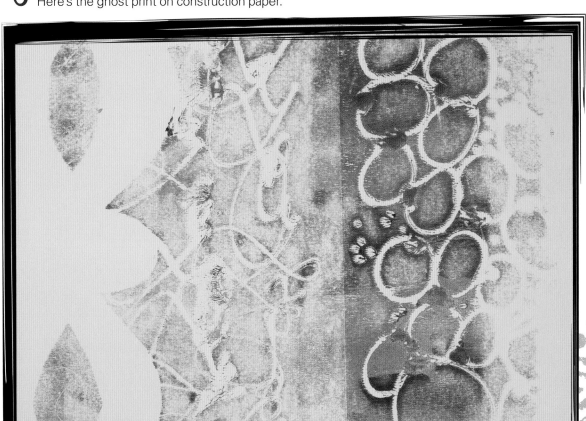

Technique
Dimensional Paint Prints

<< *Creative Toolbox*

OPEN acrylic paint

dimensional paint

11" × 14" (28cm × 36cm) Plexiglas sheet

cardstock

recycled sketch paper

paper stencils

soft rubber brayer

Dimensional paint is one of my favorite ways to add writing and doodling into my monotypes. It creates an interesting raised textured and resist in the paint when it is transferred onto paper.

1 Doodle Paint
Roll out two colors of paint onto a Plexiglas sheet. Scribble words or doodles with dimensional paint.

2 Pull Print
Place a piece of paper over the painted plate and rub the back of the paper lightly with your hands. Avoid using the brayer to burnish the back with this technique to keep the dimensional paint from spreading out too much. Pull up the paper from the corner and peel it off the plate to reveal the print.

3 Puffy Paint Print
Here's the first pull of the print. Notice I only printed a portion of the paper. To do this, place the right edge of the paper onto only half of the plate. This will ensure that the print only takes up a portion of the paper.

4 Clean Brayer
Place a paper stencil over the painted paper and roll a wet brayer over the top to clean the rest of the paint off.

84

5 **Doodle Circles**
Draw designs with another color of dimensional paint on the wet plate. When you place the tip of the dimensional paint bottle to the plate, press the bottle with even pressure as you write. This will result in fine, even lines.

6 **Print Two**
Place another piece of paper onto the painted plate to pull a second print. Carefully peel it from one corner of the plate to reveal the print.

7 **Outline Print**
Here is the second print pulled from the plate. Notice how the dimensional paint resists and creates sharp lines of color.

A series of puffy paint leaf prints.

Visit artistsnetwork.com/printmakingunleashed for free bonus printmaking projects

Hand-Cut Stencils Over Acrylic Skins

There are so many ways to create handmade stencils. Another one of my favorite materials to use it Tyvek. I recycle mailing envelopes made of Tyvek and cut out fun shapes. The material is durable and also can be used for collage elements after they've been painted, or burned with a heat gun to create quilt embellishments. In this exercise we use flower stencils cut from Tyvek to print some fun acrylic skins on Plexi. See the acrylic skins exercises in the beginning of this section for more information.

OPEN acrylic paint

11" × 14" (28cm × 36cm) sheet of Plexiglas

soft rubber brayer

Tyvek handcut flower stencils

Collage Pauge acrylic skins

1 Prepare Plate
Roll out two colors of acrylic paint onto the Plexiglas plate using a soft rubber brayer. Place hand-cut Tyvek stencils over the wet paint.

2 Acrylic Skin Print
Place a dry Collage Pauge acrylic skin face down onto the Plexiglas plate.

3 First Print
Here is the initial print of pulling the skin from the plate. This acrylic skin was made from a mixture of Collage Pauge matte and fluid paint mixed with glitter.

4 Print Stencils
Remove the paper stencils from the Plexiglas sheet and take a print. Place the painted flower onto another acrylic skin face down and roll over the back with a clean, soft rubber brayer to transfer the paint to the surface.

5 Print Flower
Take another paper flower stencil and place it on the acrylic skin surface and repeat step 4.

6 Clean Brayer
Place a third flower stencil over the acrylic skin and roll over the back with the painted brayer. This will result in the reverse print of the stencil, also called a negative.

7 Flower Prints
Remove the third flower stencil to reveal the flower prints. Set aside to dry.

8 Pull Print
Now that all the flower stencils are removed from the Plexiglas plate, place a piece of white drawing paper onto the wet paint and rub the back of the paper with your hands. Pull up the paper from one corner to check if the paint transferred.

9 Final Print
Here is the final flower plate print revealed.

Technique
Sgraffito Doodles

Scratch through the surface of the paint on a painted Plexiglas or acrylic plate to create expressive marks and doodles that will be layered on the print. Use a variety of mark-making tools to scribble and draw such as skewers, spatulas, palette knives, combs and old credit cards. Experiment with this fun subtractive Plexiglas printmaking technique to create endless unique marks!

11" × 14" (28cm × 38cm) sheet of Plexiglas

OPEN acrylic paint

soft rubber brayer

silicone brush and blade tools

Golden Clear Tar Gel

Golden Interference fluid acrylic

flower stencils

construction paper, drawing paper and cardstock

spray bottle of water

1 Scrape Paint
Squeeze OPEN acrylic paint onto a Plexiglas plate and roll out a thin even layer with a brayer. Use a silicone brush tool (I prefer Catalyst blades) to draw into the wet paint. Drizzle a mixture of Clear Tar Gel and Interference Green fluid paint over the wet surface.

2 Pull Print
Place a piece of white drawing paper onto the Plexiglas, rub the back of the paper with your hands and pull a print.

3 Place Stencils
Place flower stencils onto the center of the Plexiglas surface. Place a piece of construction paper onto the wet paint and rub the back of the paper over and around the stencils with your hands.

4 Plexi Plate
The Plexiglas plate will look like this once the print has been pulled.

5 Resist Print
The print shows the final print when you use the paper flowers as a subtractive mask. This results in the outline of flower shapes on the print.

6 Paint Surface

Add more acrylic paint to the plate and roll it with a brayer to cover the flower stencil masks. Scrape designs into the wet paint using a silicone blade tool.

7 Press Paper

Place a piece of cardstock onto half of the plate and rub the back firmly to transfer the print to the paper.

8 Pull Print

Pull up the corner of the paper to reveal the print.

9 Spot Print

Take the print from step 5 and overprint the remaining doodled flower. Place the corner of the paper onto the plate and press over the flower doodle to transfer that portion onto the paper.

10 Print Reveal

Here's the doodle flower overprint. Choose a contrasting background paper so that the prints will be bold.

11 Remove Stencil

Take the flower stencils off of the plate and spray a mist of water over the entire surface. Place another piece of paper on the surface and rub the back with your hands. Pull up the edge to make sure the paint transferred.

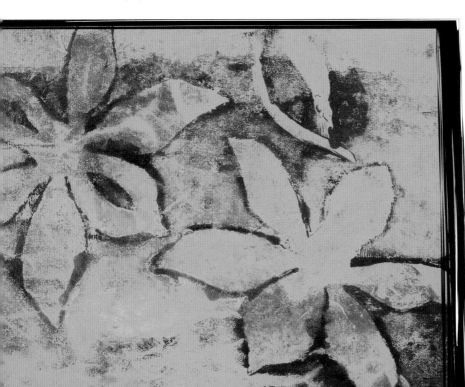

12 Ghost Print

Removing the stencils creates a sharp outline of the flower shapes. Here is the final print revealed. Set it aside to dry. Now you're ready to add doodles over the top of the painting or cut it up and use it as a collage page for your art journal.

Technique
Subtractive Printmaking

There are many variations to creating subtractive prints. The basic method is rolling out paint onto the plate, then scraping it away with various tools, brushes or rags. In this exercise, explore more ways to incorporate rubber stamps, paper stencils and doodles into monoprints.

1 Stamp Plate
Roll out acrylic paint colors onto the Plexiglas plate. Press cling mount rubber stamps into the wet paint a few times, turning the stamp in different directions. To clean the stamp, press it onto the corner of one of the printed papers.

2 Place Masks
Place flower masks over the wet painted surface, then press a printed paper onto the painted area over the flower masks. Press the back of the paper with your hands and rub the paper into the plate. This will transfer the design onto the papers.

3 Pull Print
Place a piece of binder paper over the top stencil and repeat the rubbing process in step 2. Pull the paper away from the plate to reveal the print.

4 Add Paint
Add a contrast color of paint, using a soft rubber brayer to roll it over the paper stencils.

5 Doodle Patterns
Use a silicone blade skewer or the back of a brush handle to scrape patterns into the wet paint.

6 Pull Print
Place a piece of construction paper over half of the painted plate and rub the back to transfer the flower designs to the paper.

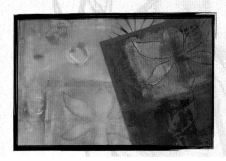

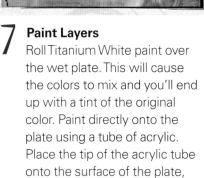

7 Paint Layers

Roll Titanium White paint over the wet plate. This will cause the colors to mix and you'll end up with a tint of the original color. Paint directly onto the plate using a tube of acrylic. Place the tip of the acrylic tube onto the surface of the plate, and lightly squeeze the tube while drawing circle designs into the wet paint.

8 Monoprint Reveal

Press a piece of dark construction paper or cardstock over the wet paint, and rub the back of the paper with your hands to transfer print to paper. Make sure to rub firmly around the area of the flower stencil masks so you get a solid print.

9 Overprint Flower

Spray the plate with a mist of water, then take a previous print and press a section of it into one of the flower masks. This will transfer the flower to the paper.

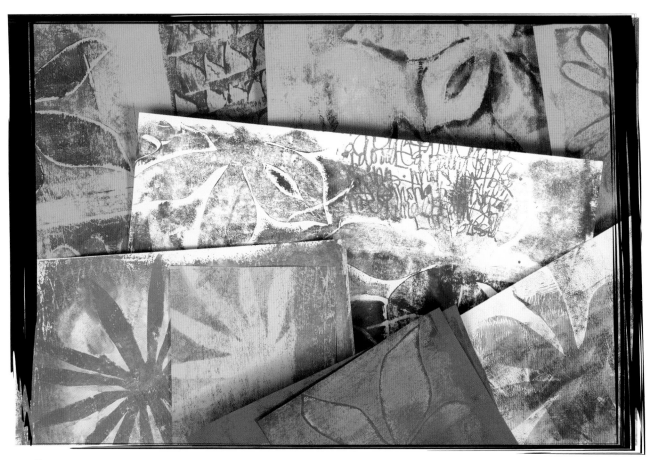

10 Prints Galore

In a short amount of time, you'll build up layers of colors on different papers. Here's the results of this printmaking session.

Visit artistsnetwork.com/printmakingunleashed for free bonus printmaking projects

Technique
Hot Glue Stencil Prints

For an organic-looking print, use some of your hot glue stencils as a mask and mark-making tool.

11" × 14" (28cm × 36cm) sheet of Plexiglas

soft rubber brayer

OPEN acrylic paint

hot glue stencils

construction paper, drawing paper and binder paper

spray bottle of water

1 Place Stencils
Roll out two colors of acrylic paint on Plexiglas plate using a soft rubber brayer. Place various hot glue stencils over the wet paint.

2 Resist Print
Place a piece of construction paper over the top of the stencils and press the back of the paper. Since the hot glue stencils are thicker, make sure to rub firmly around the edge of the stencil to pick up as much paint as possible. Pull back paper to check how the print transferred.

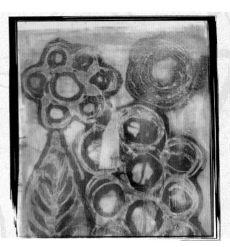

3 Print Stencil
Pull stencils off of the Plexiglas plate and place them on the print. Roll over the top with a soft rubber brayer to transfer the image.

4 Print Flowers
Continue to take all stencils off the plate and clean them by printing on the page. Repeat step 3 and print the stencils multiple times.

5 Stencil Plate
After all the stencils are removed, the plate is left with outlines of the designs.

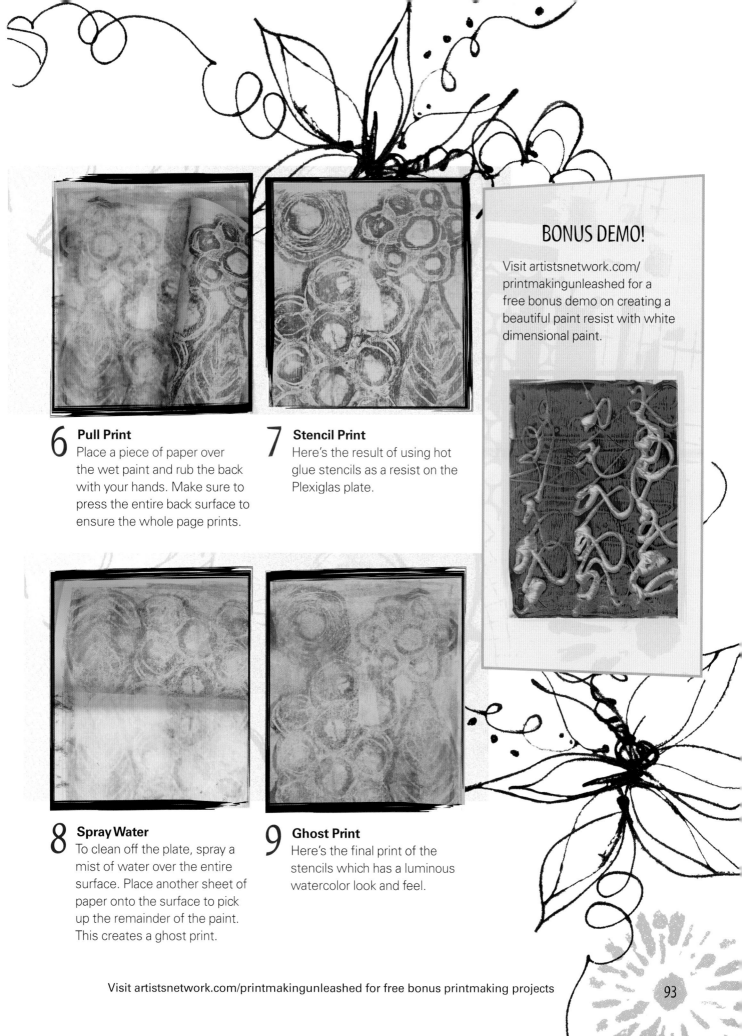

6 Pull Print
Place a piece of paper over the wet paint and rub the back with your hands. Make sure to press the entire back surface to ensure the whole page prints.

7 Stencil Print
Here's the result of using hot glue stencils as a resist on the Plexiglas plate.

BONUS DEMO!
Visit artistsnetwork.com/printmakingunleashed for a free bonus demo on creating a beautiful paint resist with white dimensional paint.

8 Spray Water
To clean off the plate, spray a mist of water over the entire surface. Place another sheet of paper onto the surface to pick up the remainder of the paint. This creates a ghost print.

9 Ghost Print
Here's the final print of the stencils which has a luminous watercolor look and feel.

Crochet String Resist

The beauty of twisted and tied yarn creates a fun circular, organic pattern on the page. Use a large crochet hook to create single strand crochet links. These chain strands will be used to print and spray patterns on the page. This technique uses a simple single crochet strand, but you could also create an intricate freestyle design of yarn to use as a mask.

<< Creative Toolbox

single crochet strands made with yarn or string

plastic page protector

ink sprays

drawing paper

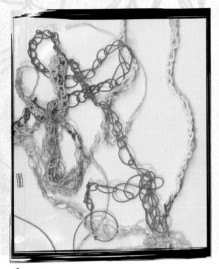

1 Crochet Strands
Place single crochet strands onto a plastic page protector. Drop them freely on the background.

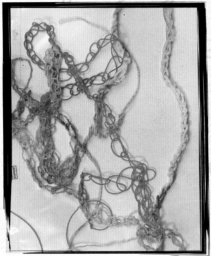

2 Paint Surface
Spray ink over the crochet strands onto the page protector.

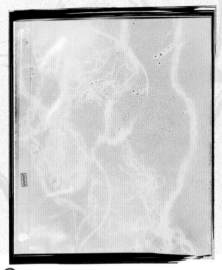

3 Print Surface
Remove the strands to reveal the print surface.

4 First Pulled Print
Place a piece of paper on the surface and pull the first print.

5 Place More Strands
Begin to build layers over the top of the first print. Drop crochet strands freely over the painting.

6 **Spray Ink**
Choose two more colors of ink sprays and alternate spraying over the crochet strands.

7 **Spray Print**
Remove the crochet strands to reveal a final print.

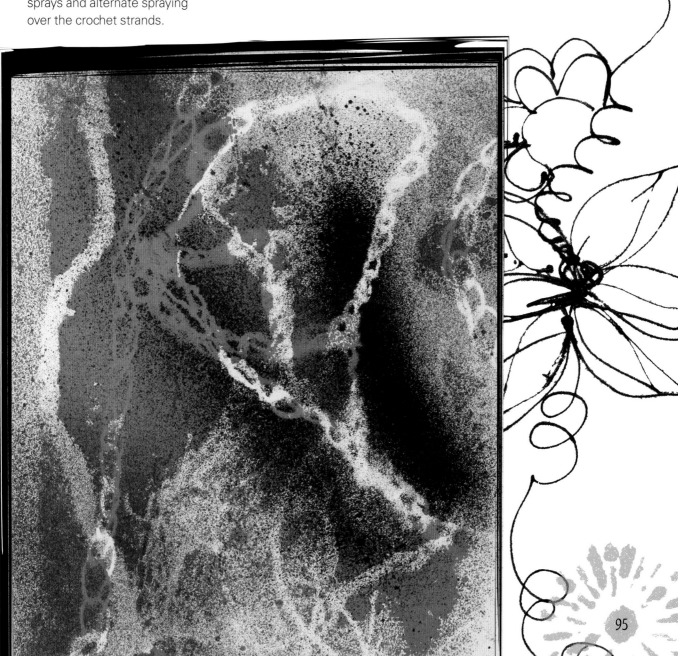

Technique
Water-Soluble Media Prints

<< *Creative Toolbox*

11" × 14" (28cm × 36cm) sheet of Plexiglas

spray bottle of water

water-soluble crayons and markers

drawing paper or cardstock

soft rubber brayer

paper towels

High Flow and OPEN acrylic paint

ink spray

zip tie stencil

Create watercolor-like lines and doodles on a printed page by drawing with markers and water-soluble crayons directly on the Plexiglas sheet. I used Derwent Art Bars and Sakura Koi coloring brush markers in this exercise.

1 Draw Flowers
Spray a sheet of Plexiglas with a mist of water. Dip water-soluble crayons into water and draw on top of the Plexi. Doodle with at least two or three colors.

2 Print Paper
Press a piece of cardstock paper onto the Plexiglas surface to pick up the doodled flowers.

3 First Print
Here is the first print revealed.

4 Clean Plexiglas
Spray the Plexi with water and wipe off any excess crayon with a paper towel to clean the surface. Draw circles, flowers and more doodles with water-soluble markers. Here I use Sakura Koi coloring brush markers.

5 Spray Water
Spray a fine mist of water over the doodled surface. Press the printed piece of cardstock onto the wet marker surface to overprint on top of the crayon flowers.

6 Second Print
This shows the print after two pulls off the Plexiglas. Set aside to dry.

7 Wash Color
Fill in the background of the page with a wash of acrylic paint using a foam brush. In this step I used High Flow acrylic paint.

8 Stencil Print
Place a zip tie stencil (see page 104) onto the print and spray with ink.

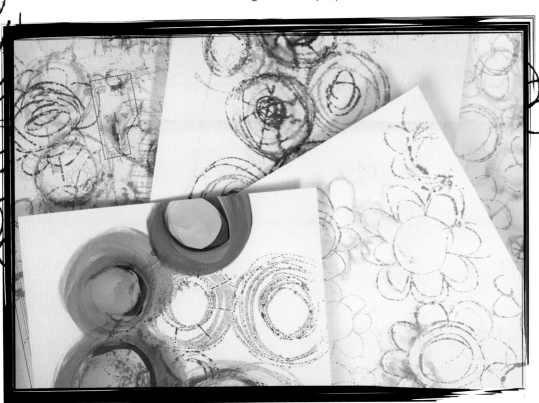

9 Samples
Various water media prints on cardstock, architectural blueprints and drawing paper.

Water-Soluble Media Printing Tips and Ideas

* Experiment with different water-soluble media such as watercolor brushed onto the plate.
* Try adding doodles with ink out of a pipette onto the surface, then print over the top.
* This is a great technique to experiment with when teaching kids about printmaking.
* Try printing on muslin and fabrics with minimal texture.

Visit artistsnetwork.com/printmakingunleashed for free bonus printmaking projects

Technique
Masking Tape Resist

Create free-form designs using torn pieces of masking tape placed on a Plexiglas plate. This technique creates interesting straight and organic lines. Experiment with different types and sizes of tape for added variety. This technique can be done on Plexi, a plastic bag or a sheet protector.

<< Creative Toolbox

painter's tape or masking tape

11" × 14" (28cm × 36cm) sheet of Plexiglas

OPEN acrylic paint

spray bottle of water

soft rubber brayer

drawing paper or construction paper

gesso fabric

paintbrush

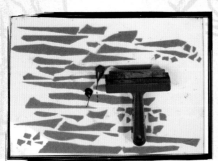

1 Prepare Plate
Tear strips and pieces of tape and adhere them to the Plexiglas plate. Place a couple of dollops of acrylic paint onto the plate.

2 Cover Plate
Roll out paint onto the Plexiglas using a soft rubber brayer. Spread paint over the entire surface.

3 Pull Print
Place a piece of drawing paper on the plate and rub the back. Pull to reveal the print.

4 Print Reveal
Here is the first print revealed.

5 Add White
Place a dollop of white paint onto the plate and roll out with a brayer. This will mix the color to create a tint.

6 Sgraffito Designs
Print on a piece of muslin covered with gesso. Place the fabric gesso side to the plate and rub the back firmly across the entire surface. Scratch the back of the cloth with the end of a paintbrush handle. Lift the fabric to reveal the design.

7 Gesso Printed Fabric
Here is the fabric print revealed.

8 Continue Printing
Place another piece of card-stock onto the wet Plexiglas plate and rub firmly on the back. Scribble again with the end of the paintbrush handle. This will create expressive marks on the printed page. Pull the paper off the plate to reveal the print.

9 Sgraffito Print
The sgraffito print revealed.

10 Remove Tape
Pull off a few sections of tape from the plate.

11 Place Paper
Place a new piece of card-stock onto the end of the plate to pull the print.

12 Spray Water
Apply a fine mist of water over the paint to reactivate what paint is left on the plate. Place the bottom of the paper back on the plate and press firmly with your hands.

13 Pulled Tape Print
Here is the final pulled-tape ghost print revealed.

Masking Tape Printmaking Tips and Ideas

* Experiment with a variety of papers, fabrics and surfaces for printing substrates. I have successfully printed on white tissue paper, paper towels, silk muslin, newsprint and bark paper.
* Prep a bunch of fabric with gesso and let it dry, then it will be ready whenever you want to print on it.
* Try creating sgraffito designs into the wet gesso before it dries.
* Paint gesso onto fabrics with a large weave such as Osnaburg fabric. This will provide a smoother surface for printing.

Technique
Recycled Plastic Prints

<< *Creative Toolbox*

Look for items with interesting textures in the hardware store such as plastic sink mats and plastic fence materials. The patterns in these pieces make great stencils and mark-making tools to add texture to acrylic skins.

- plastic page protector
- fiber paste
- fluid acrylic paint
- trowel palette knife
- bath or sink mats
- plastic fencing
- needlepoint canvas
- soft rubber brayer
- foam brush
- printed papers and skins

1 Mix Paste
Place a scoop of fiber paste onto the plastic page protector. Add a few drops of fluid acrylic paint and thoroughly mix with a palette knife. Use the bottom of the palette knife to spread the mixture over the entire surface of the plastic sheet in a flat, even layer.

2 Make Impression
Place a plastic bath mat with circular shapes in the wet fiber paste mixture. Then place plastic fence material and pieces of plastic needlepoint canvas over the surface. Roll over all the items to press them into the paste.

4 Dab Paint
Continue to paint through the stencil. Lift the edge up to see how the texture is showing and the paint is mixing.

3 Paint Pattern
Remove the plastic fence material and needlepoint canvas. Add a little fluid acrylic paint to the edge of a foam brush and dab the brush through the sink mat. This will mix with the wet paste and blend colors. Add a few drops of fluid white paint.

5 Print Reveal
This is the final print. It will dry to a matte rough texture. Set aside to dry.

6 Clean Plastic Mat

While the bath mat is still wet and covered with fiber paste, transfer the remainder paste by pressing it over previously printed papers and skins.

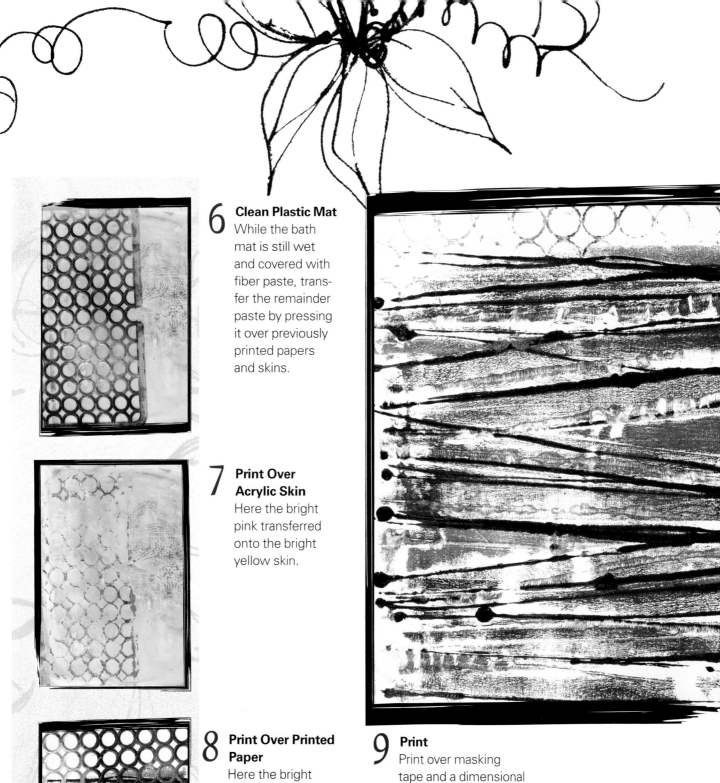

7 Print Over Acrylic Skin

Here the bright pink transferred onto the bright yellow skin.

8 Print Over Printed Paper

Here the bright pink transferred onto the green lines of a previously printed page.

9 Print

Print over masking tape and a dimensional paint print.

Visit artistsnetwork.com/printmakingunleashed for free bonus printmaking projects

Technique
Doily Print Collage Plates

<< Creative Toolbox

Plexiglas offers so many exciting possibilities for pulling color and prints on paper. Sometimes these techniques can be done without paint or ink but instead by using paper that will release a dye, like bleeding tissue paper. I love working with bleeding tissue paper in my collage work and combining it with textures such as doilies or lace.

- bleeding tissue paper
- scissors
- heart-shaped doilies
- 11" × 14" (28cm × 36cm) sheet of Plexiglas
- spray bottle of water
- drawing paper or construction paper
- soft rubber brayer
- Collage Pauge drizzle screen (see online bonus section)
- free-motion stitched transparency plate

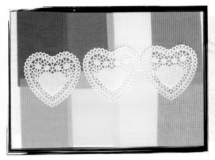

1 Collage
Cut and arrange several pieces of bleeding tissue paper. Use analogous colors, since these will mix when wet. Place heart-shaped doilies over the tissue paper.

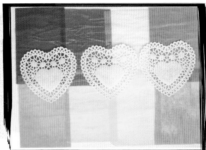

2 Spray Water
Cover the entire surface of the collaged Plexiglas plate with a fine mist of water. Make sure all paper is damp and covered with water; it will start to bleed at the edges where the papers are overlapped.

3 Pull Print
Place a piece of white drawing paper over the wet plate and press firmly on the back of the paper. Roll over it with a brayer or your hands, paying close attention to the outer edges of the doilies.

4 Print Reveal
Here is the dyed doily collage print. Since the doilies are wet, sometimes they will stick to the printed page. Notice that the middle doily heart stuck to the paper when the print was pulled. Let it dry. To keep the doily in place, brush on a layer of Collage Pauge to seal it to the paper.

5 Add Paper
Cut a couple more pieces of tissue paper and place them over the lighter papers that have a little color left. Spray the surface with water. Place another sheet of drawing paper over the collage plate, then lay a Collage Pauge drizzle screen over the top. Roll over the entire screen/paper sandwich with a soft rubber brayer.

6 Reveal Print
Pull up the edge of the paper to check if the color transferred.

7 Drizzle Screen Overprint
Here is the first ghost print revealed.

8 Print Flowers
Spray the collage plate with water to saturate the bleeding tissue paper. Place a new sheet of drawing paper over the wet paper, then a free-motion stitched transparency plate. Roll over the transparency plate with a soft rubber brayer.

9 Reveal Print
Pull the edge of the paper up to see the placement of the stitched flowers. Continue to add more prints until the paper is filled.

10 Stitched Print
Here's the print of the free-motion plate. This is a great base to paint a wash, then doodle over the top or use it for collage paper for your art journal.

Working With Bleeding Tissue Paper Tips and Ideas

* Experiment using various mark-making tools over the top, like hot glue stencils or cardboard stamps.
* Place bleeding tissue paper over texture plates and run them through a pasta or die-cut machine to press the color and texture to paper.
* Once you are finished with the bleeding tissue paper on the plate, carefully transfer the colored paper onto a plastic sheet protector and brush on Collage Pauge to create a collage acrylic skin.

Visit artistsnetwork.com/printmakingunleashed for free bonus printmaking projects

Zip Tie Stencils

zip ties

muslin or drill fabric

ink spray

white and printed papers

Who needs zip ties for holding things together when you can use them to create intricate stencil designs? Zip ties (or cable ties) come in many colors and sizes. They are made of plastic and can be connected to create interesting shapes. I make free-form zip tie stencils by connecting them together, adding one at a time, then gathering a few and pulling them together and securing them with another zip tie. The possibilities are endless. Create a few zip tie stencils and use them as designs in your printmaking!

1 Zip Tie Prints
Place zip tie stencils on top of piece of drill cloth. Spray over stencils with spray ink.

2 Print More
Place more zip tie stencils over the first set of prints. Spray again with a different color of ink.

3 Print Stencils
Remove the zip tie stencils and turn them over one at a time on the fabric. Roll over the back of the stencil to transfer the print of the painted side. Since there is only a little paint, the stencil prints will be light.

4 Overprint
Take the previous prints and place a different zip tie stencil over the top and cover with ink spray.

5 Final Print
Remove the zip tie stencils to reveal the final print.

Printing Fun With Zip Ties

* Create a very large zip tie stencil to cover a 30" × 30" (76cm × 76cm) canvas. Create multiple stencils in that size to experiment with over-printing them.
* Use the zip tie stencils on Plexi and spray over the top to pull prints.
* Place zip ties over Collage Pauge acrylic skins and make prints.

Technique
Foam Stamp Prints

I love to make my own stamps with craft foam. Experiment making your own foam stamps and incorporate them in Plexi printmaking!

1 Stamps
A collection of my craft foam leaf-shaped stamps. Some are cut pieces and others are inscribed with lines to create the leaf shapes.

2 Paint Plexi
Drizzle out fabric paint onto the Plexiglas and roll it out into a thin layer over the entire surface.

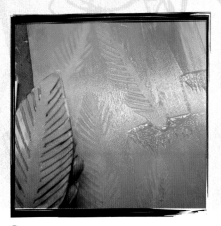

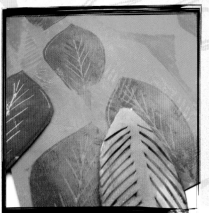

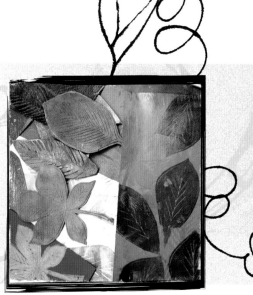

3 Press Stamp
Randomly press the leaf stamp into the wet paint on the plate in different directions. Place a sheet of construction paper over the top and rub the back to transfer the print.

4 Print and Stamp
Press the painted leaf stamp over the top of a print to clean the stamp, then print over the top with another leaf stamp.

A collection of inscribed craft foam stamps and prints.

Visit artistsnetwork.com/printmakingunleashed for free bonus printmaking projects

Color Palettes

Here are some more colorful palettes to inspire your mark making. Find more ideas at the end of each section in the book.

Spray paint through a handmade hot glue stencil with fabric sprays on Osnaburg fabric. This color palette is inspired by autumn leaves: shades of green, copper and brown.

Monoprints on muslin; sprays from the fabric paint through hot glue stencils. Color palette: violet, black, hot pink and indigo

A color palette of blue copper and cream buff made with handmade stamps on tissue paper.

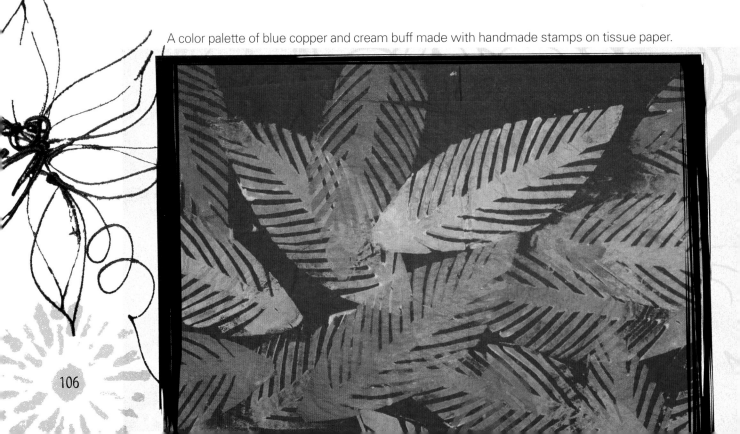

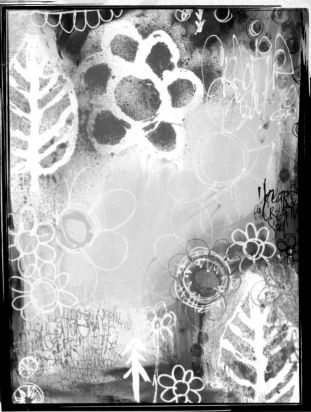

Paint swatches of color palettes in your art journal with a wide flat brush. Use a hand stamp to add a contrasting color. This is color palette is made of purple, pink, orange, yellow and forest green.

Spray acrylic ink through hot glue stencils on a piece of mixed-media paper. With a wide brush, paint in a background with acrylic paint. Doodle with dimensional paint and a white correction pen.

Create a color palette with swatches of acrylic paint, then repeat the color palette with scribbles of colored pencils.

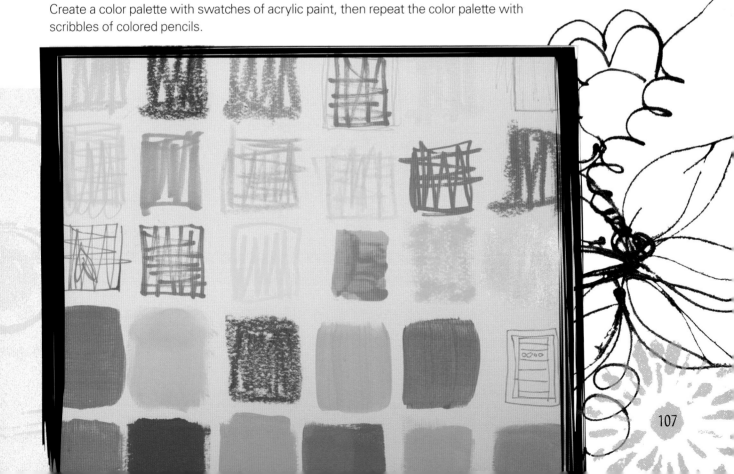

Part 3

Printmaking Projects & Inspiration

This final section ties many of my mixed-media tools and techniques together. I share a variety of pieces—some finished, some in process— as a guide to inspire you to develop your own creative style. When I create my artwork, it's a free-flowing exercise of creativity. I let each mark unfold intuitively, trusting the process, letting my creative soul guide me. My hope is that when you flip through this section an idea will spark from seeing a shape, a color, a mark. You'll find a whole bunch of creative jumpstarts to use as a springboard for your imagination. Remember, there is no single way to create a piece. I encourage you to take some time to create a collection of tools shown in section one and to practice the techniques in section two. Develop your style and be inspired!

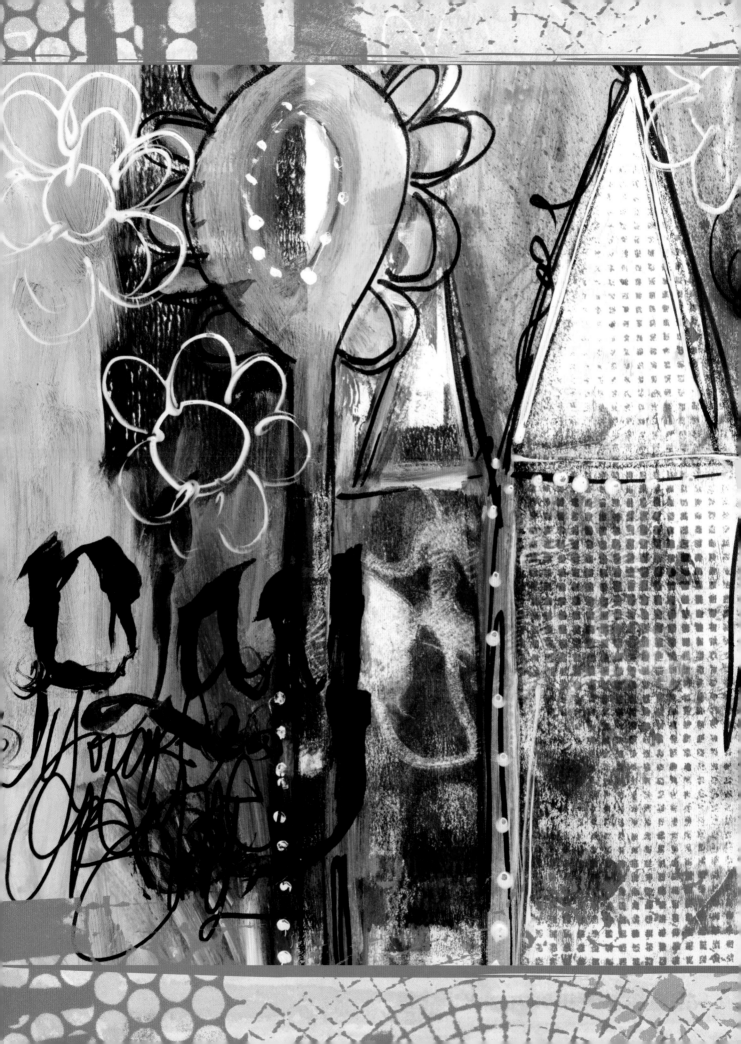

Building Layers Over Prints

Here is a collection of mixed-media recipes to help inspire your own layered paintings. Take notes on the techniques that catch your eye and make a set of creative jumpstart cards. Simply write your favorite ideas on cards and put them in a box or jar. If you feel stuck or need a little push, pull out a prompt and add a mark to your canvas. Add your own creative twist by combining a few or a lot of ideas into one piece.

Dye muslin. Spray through a flower stencils. Monoprint fabric with dimensional paint. Collage painted paper. Free motion-stitch designs and doodles. Write "play" in stitches. Use this free-motion art quilt piece as a fabric journal cover.

Sgraffito paint; wipe out paint on Plexi with a craft stick. Take a print. Paint eggplant, olive and powder puff blue. Paint circles; outline them with a darker color. Draw with a green highlighter. Write with a glue pen. Sprinkle glitter.

Spray paint through needlepoint canvas. Paint turquoise, white and brown. Draw feathers and flowers with a paintbrush. Make lines with a thin brush. Add dots of white. Make marks with a fluorescent pink paint pen. Paint on a brown grocery bag or craft envelope.

Print rubber stamps with inks in five different colors. Stamp with pyrogravure wood blocks and black ink. Write a mantra in gel pen. Paint messy lines in yellow and fuchsia. Print a stencil with a rubber brayer. Scribble with colored pencil. Doodle patterns with black and silver paint pens.

Paint background with gesso. Press silk flowers into wet gesso or paint. Collage black and white flowers. Draw and write with a black chisel-tip marker. Write with a white correction pen. Draw flowers. Brainstorm words by writing about your garden. Write a quote about flowers, bees or vegetables.

Spray purple paint through sequin waste. Draw a honeycomb pattern. Use a silk flower as a mask; when it's full of color, print the flower on the page. Cover page with gesso. Draw flowers with colored pencil. Write words with a brush marker. Journal prompt: beautiful soul.

Paint a wash of color on fabric. Free-motion stitch circles. Adhere rub-on decals. Cut out shapes from pattern paper. Take a photo of a bridge. Cut apart a photo and collage it onto the page. Write words with a black fabric pen. Write the word "wonder." Stitch flower designs.

Roll out paint with a brayer on kids' storybook paper. Take a print with red dimensional paint. Print your paintings on white full sheet labels to create stickers and art tape. Cut pieces of tape and use them for collage or decoration. Take a photo of your studio space. Draw with a white oil pastel. Write about your creative soul. Draw black flowers. Add turquoise tape to the page.

Make the Most of Your Artwork

* Take photos while you are creating a piece at different stages.
* Photocopy or scan the final artwork.
* Print artwork in black and white to use as collage sheets.
* Print artwork on inkjet fabric sheets or on acrylic skins.
* Make stickers by printing artwork on label paper.
* Stack multiple pieces of artwork to create digital layers.
* Print photos of your artwork and collage them into your day planner.

Paint over a black-and-white photocopy of your original artwork. Color block areas with different shades of green. Draw squares and rectangles. Draw circles. Draw a stylized face. Make marks with white oil pastel.

Mix molding paste and paint; spread it on fabric with a palette knife. Cut out a flower. Print with a sink mat with circle pattern. Create a dimensional flower decal. Cut out cloud shape. Collage acrylic skins to fabric. Stamp into molding paste with a rubber stamp. Paint with yellow and pink.

Spray orange ink through plastic needlepoint canvas. Stamp designs with torn cardboard. Paint pink dots with a bingo marker. Scribble words into paint with the tip of the handle. Draw yellow lines with an oil paint stick. Draw a heart. Draw flowers with dimensional paint. Stamp a flower.

Substrates and Surfaces

I use a variety of surfaces for my mixed-media creations. Nothing is off limits, from rice paper, cardboard and newsprint to bark paper, wood and plastic. Experiment with different substrates for a variety of results. Here is a sampling of ideas to inspire you.

Brown paper bag.

Kids' storybook paper.

Newspaper and newsprint.

Paper towels.

Fused plastic bags.

Drill cloth, muslin or canvas.

Visit artistsnetwork.com/printmakingunleashed for a free bonus printmaking projects

Graffiti Canvas and Painted Cloth

My graffiti canvases are fabrics smeared with paint and colorful layers of stencils, stamps, freestyle lettering and patterns. Some are as small as 8" × 8" (20cm × 20cm) and others up to 50" × 60" (127cm × 152cm). I use a variety of fabrics from muslin and drill cloth to canvas and Osnaburg.

Spray through stencils. Combs, sequin waste, silk flowers, silk leaves and architecture stencils. Stamp patterns with handmade craft foam stamps and pink foam hair curlers. Print with needlepoint canvas. Brush on white paint, then dye it with a bright color. Spray red through an alphabet stencil. Draw flowers with white dimensional paint.

Paint circles with a foam brush dipped in blue fabric paint. Paint with a thin round brush dipped in India Ink. Paint circles and flowers. Doodle with pink and red dimensional paint. Draw with a black pen.

Spray purple paint through circle stencil. Spray green paint through sequin waste. Cut cardboard shapes and place them under fabric. Rub cardboard shapes with paint on a foam brush. Draw with red dimensional paint. Make marks with green marker.

Draw lines with red dimensional paint on a transparency and print it. Place a texture plate under the fabric and rub with oil pastel. Spray through stencil and print it. Dab orange paint with a foam pouncer. Doodle blue circles. Draw with a black marker and blue dimensional paint onto HeatnBond Lite; fuse it to fabric. Transfer a color laser image with Collage Pauge.

Paint over canvas with India ink using a small round brush on drill cloth.

Needlepoint canvas circles and number stencils on muslin.

Free-motion stitch a Girlie Glam face on hand-dyed and marbled jean fabric.

Paint with hot glue stencils in leaf shapes; doodle leaves with dimensional paint on Osnaburg fabric.

Print alphabet stamps and number stencils on muslin.

Color and Mark-Making Inspiration

My artwork explodes with color. I am inspired by everything that enters my path. I take photos of flowers, leaves and color combos I see in nature. I also collect swatches of my paintings, fabrics and papers to create inspiration flair trays and color boards. Gather your favorite color combinations and create vignettes to hang on your wall or paint in your journal.

Color palette swatch cards made by placing small collages of color swatches in baseball card holder.

Eggplant, black, gray and lavender.

Spring fling palette—lime, yellow, pink and orange flair tray.

Place color-coordinating dyed fabric swatches inside plastic sheet protectors and hang them on a bulletin board or wall for inspiration.

Turquoise, black, fluorescent pink and fluorescent orange.

Rust, purple, aqua and orange clipboard inspiration palette.

Place needlepoint canvas under a photo and rub with sandpaper to alter a photo. Paint circles with a bingo dauber. Brush doodles with India ink.

Use a large envelope as a surface. Paint with kids' foam blocks dipped in paint. Print five squares. Cut a heart stencil and print it. Roll bright green paint onto the canvas with a brayer.

Roll out black paint on Plexi with a soft rubber brayer. Scribble into paint with a skewer. Write words with black dimensional paint. Place paper over painted Plexi and pull a print.

Cut apart a strawberry basket to create a stencil. Paint through a basket stencil. Draw a circle. Paint red with the tip of a flat brush. Draw with a black pen. Write ten words.

Draw a Girlie Glam face. Spray through stencils. Paint on muslin fabric. Create a circular stencil with a hot glue gun.

Turn paper stencil masks into collage embellishments and gift tags. Cut a leaf shape. Decorate shape with dimensional paint. Draw with a pipette filled with India ink. Cut out a feather shape. Stamp with a rubber stamp using paint. Sprinkle glitter. Collage stencil to painting.

Gesso Fabric Prints

Gesso is used to prime a substrate for painting, but I love to use it as a resist and to incorporate texture into my canvas. Try a few of these ideas!

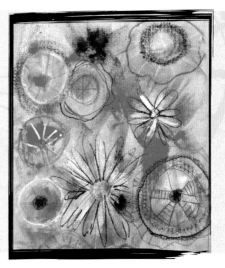

Paint the muslin with gesso, then scratch designs and words into it with a skewer. Print hot glue stencils with gesso to create flower pattern.

Paint through stencils with gesso. Set aside to dry and paint over gesso with acrylic wash to tint it slightly. It will also act as a resist.

Paint circles and flower shapes with gesso on a piece of Osnaburg fabric. Let dry. Paint a few abstract flowers with acrylic. Draw and doodle with various markers and pens over the top of the dry paint.

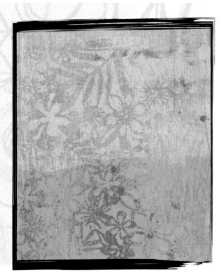

Brush gesso onto fabric. Set aside to dry. Wash fabric with warm water and place in the dryer on high heat until completely dry. This will cause the fabric to look distressed. Overdye the washed gesso with fabric dye. Spray through stencils with fabric sprays.

Gesso Tips and Ideas

* Experiment with mixing color into gesso.
* Try painting with black gesso.
* Gesso can be used as a resist. Paint a design, then paint a wash over it when it's dry. Wipe back any excess paint with a paper towel.
* Paint gesso through a stencil to add texture to the surface.
* Paint the back of a stencil with gesso and press it onto the surface to take a print.
* Make distressed gesso fabric by washing the fabric, then painting over it.
* Scratch textures into gesso with various mark-making tools.

Paint Recipes
Idea Journals

Idea journals are simple, easy-to-make notebooks. I take a bunch of my printed papers, tear them down to different sizes, stack them together, fold on one end and sew a zigzag stitch right down the center of the fold. These make great art journals, sketchbooks or a place to store your ideas. The covers can be made of painted fabric, free-motion stitched art quilts, a collage of monoprints or a simple painted manila folder. Use maps, ephemera collected from travels, atlas pages, blueprints, graph paper and music sheets as pages. Staple, tape or stitch art journal cards or inspirational photos inside. Include paint chip cards for color inspiration. Wrap the center of the journal with twine, hemp or crochet yarn and embellish with flowers. Anything goes!

Idea notebooks made of stitched collage covers and fabric. Fold a manila envelope in half and stitch up one side to create a pocket.

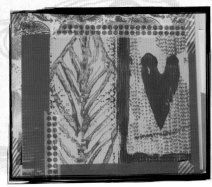

Monoprint of hot glue and heart stencil on construction paper, taped to painted manila folder.

Altered photo stapled to a printed manila folder.

Fold some pages shorter than others. Use construction paper, newsprint and manila folders for journal pages.

Use a free-motion texture plate to add designs over the page. Stitch photocopies of your artwork into journals.

Recycle bingo paper, graph paper for pages. Print with silk flowers, plastic gutters, needlepoint canvas and doodle dimensional paint monoprints.

Create prints with rubber bands, hot glue flowers and paint with a dauber. Use duct tape or masking tape to secure pages inside the idea journal.

all mixed up
Four-Panel Cut-Out Collage

<< *Creative Toolbox*

assortment of printed paper

scissors

four panels of 6" × 6" (15cm × 15cm) clayboard

Collage Pauge matte

foam brush

wet paper towel

This is a great project for incorporating a variety of colorful printed papers. Practice pulling prints from the techniques in section two and have fun collaging them into unique new artworks!

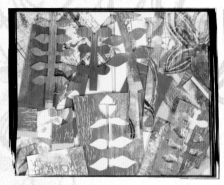

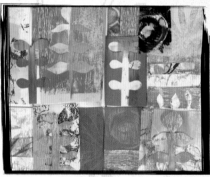

1 Cut rectangles and paper flower shapes out of printed papers.

2 Plan out the collage by placing them on four clayboard panels.

3 Brush Collage Pauge onto each of the clayboard surfaces. While wet, continue to place more collage pieces and brush on another coat of Collage Pauge to seal the paper. Smooth out air bubbles by rubbing the top of the paper with your fingers. Repeat until the entire surface is covered with paper. Add a final layer of Collage Pauge.

All Mixed Up
Girlie Glam Digital Canvas

My signature drawing is the Girlie Glam face. She has made her appearance in all of my books. With the advent of digital tablets like the iPad and amazing art apps, here is a project you can create by painting on a tablet using a stylus. The tablet is great to use as an extension to your art. It's perfect for the times when you don't want to pull out all the paints and brushes or when you are traveling on an airplane. Have fun experimenting and drawing a stylized face in ArtRage!

1 Open ArtRage for the iPad. Create a new canvas. Take a photo of a painted background. Create a new layer. Draw over photo using colored pencils. Airbrush the word "love."

2 Import a stencil painted background and blend the layers.

3 Write words and draw circles with a white crayon. Trace the flower stencil with a marker.

4 Blend the layers. Draw a face with a pencil in another layer.

5 Paint details in the face, add hair, paint lips with the Airbrush tool. Write more words with the Airbrush tool.

Digital Canvas Tips

* Technology changes so fast; there are always cool new apps, programs and tools. My current favorite digital painting apps are ArtRage, Procreate, Noteshelf and PaperByFiftyThree.
* Use a stylus to control the line for detailed drawings.
* It's easy to undo mistakes you don't like.
* Try this project with traditional paints and art materials!

Color Palettes

My studio is always in creative chaos. It's messy, with lots of things on the tables, in shelves and in open containers. But when you walk in, there's colorful inspiration everywhere you look. I love to showcase my collections to inspire my color palettes and paintings. I display my painting tools in vintage glass containers, place beads in teacups and saucers from the thrift store, hang work in progress on the walls and pull together various embellishments and fibers in flair trays for project jumpstarts. Here's a peek into my studio.

Resources

Visit printmakingunleashed.com for additional resources, video tutorials and updated information on *Printmaking Unleashed*!

Take an online mixed-media workshop with me at **treicdesigns.com**.

Be inspired & connect with me!

blog: **kollaj.typepad.com**

 facebook.com/TraciBautista

 flickr You**Tube** **g+**

@treiCdesigns

Traci Bautista Custom Art Tools

treicdesignsdigitals.com
digital art journaling kits including workbooks, brushes, fonts and printables

stampington.com
Graffifi Glam art stamps by Traci Bautista

Other Supplies

ampersandart.com
paper, boards and other substrates

clearsnap.com
Colorbox stamp pads and ink sprays

discountschoolsupply.com
Colorations Liquid watercolors and spray bottles

encausticpaints.com
Enkaustikos Wax Hot Sticks and other wax supplies

fiskars.com
scissors, Fuse machine for die cuts and letterpressing

goldenpaints.com
fluid, High Flow and OPEN acrylic paints; gesso, molding paste, fiber paste

grafixarts.com
Dura-Lar

ilovetocreate.com
Collage Pauge, Tulip Slick Dimensional Paint, Tulip Soft Fabric Paint, foam pouncers, Aleene's dry adhesives and tacky glue

roc-lon.com
super muslin, Osnaburg fabric

sakuraofamerica.com
Pigma Sensei permanent ink pens, Koi Coloring Brush Markers, Koi travel watercolors, Specialist oil pastels, solid paint markers

speedballart.com
soft rubber brayer and Akua paints

stencilgirlproducts.com
Stencil Girl products

strathmoreartist.com
Mixed Media paper and journals

walnuthollow.com
Creative Versa-Tool, wood burning

Library

Lulu by Lulu de Kwiatkowski
Nomad by Sibella Court

Pattern by Orla Kiely
Rethinking Acrylic by Patti Brady

Index

About the Author

Once a corporate go-getter in the Silicon Valley, Traci left a successful marketing and graphic design career in 2001 to pursue her passion for art and share her love of creativity with people worldwide. Focusing her artistic energy into treiC designs, she has become an accomplished mixed-media artist, creative entrepreneur, instructor and author of two bestselling books, *Collage Unleashed* and *Doodles Unleashed*. She has been featured on HGTV's DIY Network's Craft Lab and in fifteen art and mixed-media books, numerous blogs and more than forty craft magazines including *Somerset Studio, Altered Couture, Cloth.Paper.Scissors, Art Journaling, Somerset Digital Studio, Art Quilting Studio, Belle Armoire, Craft* and *Where Women Create*. For the past twelve years, she has traveled the world teaching mixed-media workshops and speaking about creative business. She has developed and launched creativityUNLEASHED, an online learning website and art community that includes twenty-five e-courses in handmade books, art journaling, creative business, and surface design. Her creative business includes designing licensed product lines, Aleene's Collage Pauge adhesive, Graffiti Glam rubber stamp line with Stampington & Co. and {kolLAJ} paper crafts. She designs digital art journaling and mixed-media products for her own digital shop, treiCdesignsdigitals.com. She owns {studio 323*7}, her art studio and boutique in Danville, California. You can follow her creative journey at treicdesigns.com.

Acknowledgments

This colorful life I lead has been an amazing journey. I'd like to thank the many artists who have crossed my path in person and online. Thank you for sharing in my creative journey.

To the team at F+W Media, who has championed my ideas and helped me put together three books that I am proud of. A special thanks to my editor, Sarah Laichas: thank you for helping me pull everything together and being flexible through all the roadblocks.

To the team at ILoveToCreate: you continually give me amazing creative opportunities to take part in.

To my mentor and friend, Sherill Kahn, who has always been there from the beginning and throughout my career offering guidance and sharing openly about this industry.

To Patti Brady and Golden Artist Colors: thank you for your incredible and giving spirit.

Thank you to everyone who has touched my life and encouraged me to follow my dreams. I am truly doing what I love. With gratitude, love and light … thank you.

Dedication

To my loves, Tyler and Indie

To my family: Papa, Ma, Dude, Pua, Nugz and trei*trei*

Thank you from the bottom of my heart for your support, encouragement and being my cheerleaders.

I love you.

Other fine North Light Books are available from your favorite bookstore, art supply store or online supplier. Visit our website at fwmedia.com.

18 17 16 15 14 5 4 3 2 1

DISTRIBUTED IN CANADA BY FRASER DIRECT
100 Armstrong Avenue
Georgetown, ON, Canada L7G 5S4
Tel: (905) 877-4411

DISTRIBUTED IN THE U.K. AND EUROPE
BY F&W MEDIA INTERNATIONAL LTD
Brunel House, Forde Close, Newton Abbot, TQ12 4PU, UK
Tel: (+44) 1626 323200, Fax: (+44) 1626 323319
Email: enquiries@fwmedia.com

DISTRIBUTED IN AUSTRALIA BY CAPRICORN LINK
P.O. Box 704, S. Windsor NSW, 2756 Australia
Tel: (02) 4560 1600; Fax: (02) 4577 5288
Email: books@capricornlink.com.au

ISBN 13: 978-1-4403-3391-0

Edited by Sarah Laichas
Editorial layout by Beth Erikson
Designed by Bethany Rainbolt
Cover designed by Wendy Dunning
Production coordinated by Jennifer Bass

Metric Conversion Chart

To convert	to	multiply by
Inches	Centimeters	2.54
Centimeters	Inches	0.4
Feet	Centimeters	30.5
Centimeters	Feet	0.03
Yards	Meters	0.9
Meters	Yards	1.1